CAPTURING
the light

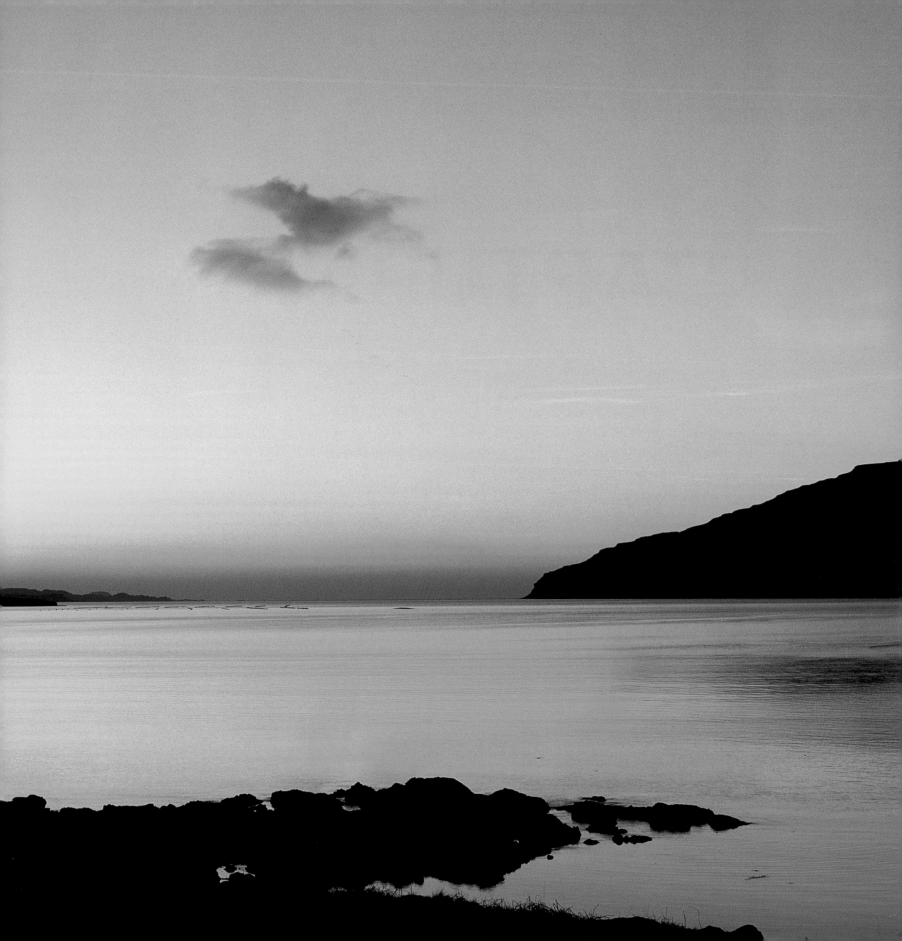

CAPTURING
the light

**An inspirational and instructional guide
to landscape photography**

PETER WATSON

photographers'
pip
institute press

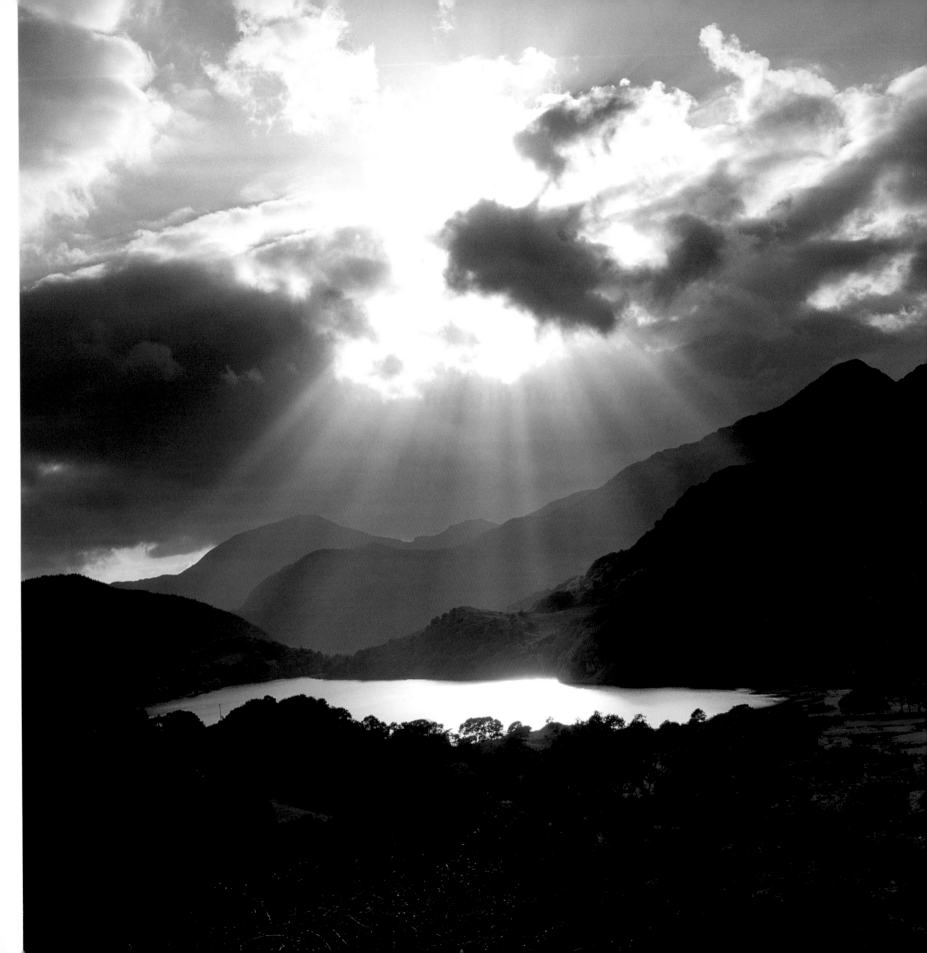

CONTENTS

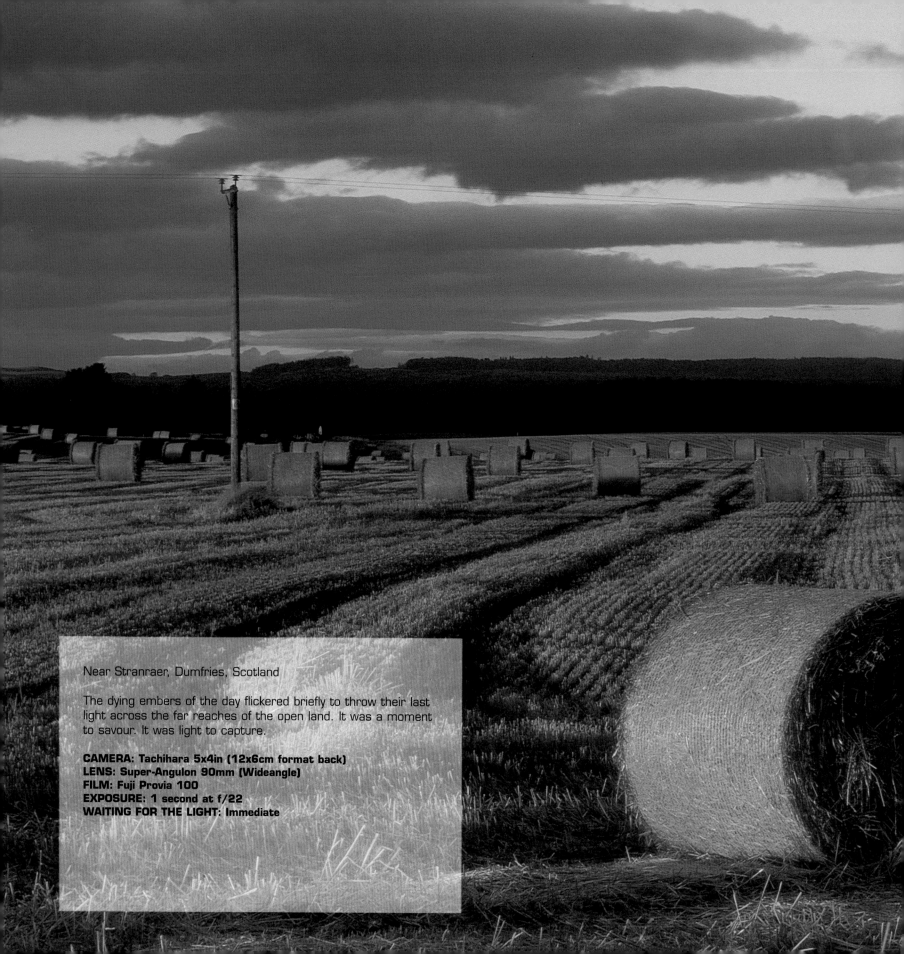

Near Stranraer, Dumfries, Scotland

The dying embers of the day flickered briefly to throw their last light across the far reaches of the open land. It was a moment to savour. It was light to capture.

CAMERA: Tachihara 5x4in (12x6cm format back)
LENS: Super-Angulon 90mm (Wideangle)
FILM: Fuji Provia 100
EXPOSURE: 1 second at f/22
WAITING FOR THE LIGHT: Immediate

Introduction

Why, I often ask myself, do I find the landscape so compelling? What is it that draws me in? When – if ever – will I tire of its moods and whims? What? When? Why? The questions remain unanswered but I think that, like any visual artist, I seek freedom of expression. But perhaps I seek more than this. Perhaps I am driven by the challenge. I cherish the pursuit, the thrill of the chase. I want to experience the 'Eureka! I have it! The landscape is mine!' moment. This is what the landscape gives us and this is what entices artists of every ilk into its lair.

Looking back over my most memorable experiences, I realize now that they all share a common quality. Without exception, my 'Eureka' moments were those when I successfully captured the light. They were the elusive, fleeting occasions when the trinity of light, land and photographer joined together, triumphantly, to seize and preserve the passing glory. This is a product of the synergy that develops between the photographer and landscape, and it is this relationship that is the driving force behind truly distinctive image-making.

This is not about technique; technical ability is merely the hidden foundation on which we build our pictures. Photography, like any art form, must be felt and it must be loved. Photographers who have a love for the landscape can feel a photograph coursing through their veins. Their experience is immeasurably more than the simple, physical act of making an exposure. They have, perceptively, allowed the landscape to capture their hearts and they, in return, capture the light.

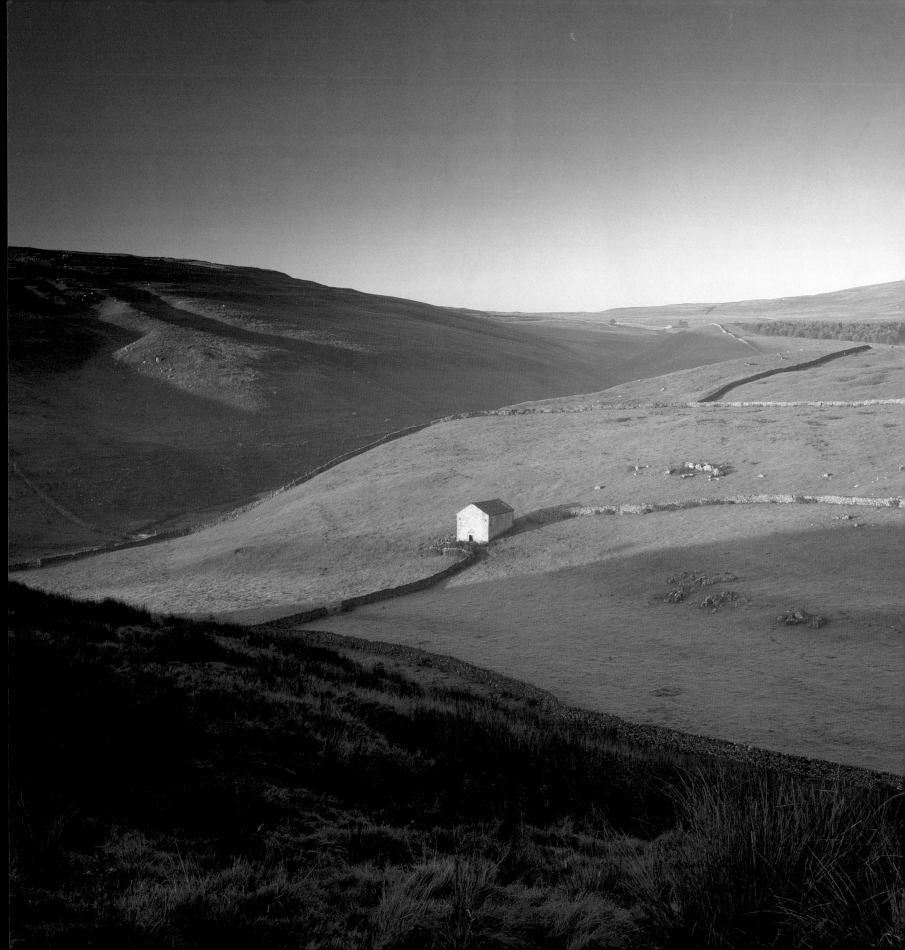

CHAPTER ONE

Understanding Light and Colour

Beauty, it is said, is in the eye of the beholder. Evidently this must be true because the work of art that is universally acclaimed and appreciated does not exist. Aesthetic qualities are viewed subjectively and judgements made, good or bad, right or wrong; however, that said, there is a common denominator which distinguishes the work of artists who have gained strong reputations. The singular quality that sets their work apart is impact. Their art makes an impression; it communicates, it speaks to its audience and it generates an emotional response. And this, perhaps, is the only rule that applies: to gain a following, art must have impact. So, as landscape photographers, how do we achieve this elusive – and largely intangible – quality?

To answer the question I look back to earlier centuries when painting flourished as an art form. In particular I consider the work of Rembrandt, whose masterly rendition of the impression of light produced paintings that would immediately engage the viewer. His work had a quality which was, and remains, truly distinctive. Now, four hundred years later, little has changed. Light continues to stand alone as the foundation on which distinctive works of visual art are built.

In the field of landscape photography, light is preponderant. There is no escape from its domination of the land we inhabit. Light is fickle; its quality, quantity, direction and colour dominate the thoughts and actions of the outdoor photographer. We must learn to understand it, appreciate it, anticipate its fleeting whimsicality and, above all, we must learn to use it wisely. Photographers, like our ancestral peers, must learn to become masters of light.

The Power of Light

Every landscape has a personality. There are those that exude magnificence on a grand scale, while others display a more subtle, understated charm. The enchanting Yorkshire Dales fall unambiguously into the latter category.

This is a land of farms, hills, dales and pastures, and for photographers it is also a land of immense opportunity. The light and weather can be unpredictable but, frustrating as this can be, such conditions give the landscape an ever-changing appearance. Photographs can suddenly appear as light plays across the hills and valleys, and rewarding results can be achieved with patience and observation.

I spent several hours one day simply watching and waiting as varying combinations of sun, showers and cloud drifted across the Upper Wharfedale Valley. The light was sometimes soft, sometimes intense and the sky varied from the bland to the dramatic. But, despite the generally favourable conditions, I wasn't totally satisfied. It was the direction of the light which was the problem. I was looking north

towards Kettlewell with the sun behind me, which meant the valley was frontally lit. I felt that a landscape on this scale would benefit from sidelighting, so I returned early the next morning when the sun (weather permitting) would be in a low position to my right.

A bank of mist hung in the valley as dawn broke. It was grey and dreary but time was on my side. After an hour or so the mist gradually cleared and sunlight began to filter through broken cloud. My expectations were surpassed as the early morning light crept along the valley floor to give the landscape texture, colour and shape. The foreground has, in particular, benefited from the low, obliquely angled sunlight. It has been transformed from a rather mundane area of grass into a field of rich fabric and delicate hues.

I think this photograph very effectively reflects the personality of the Yorkshire Dales, but taking it served to remind me that, no matter how spectacular a landscape might be, ultimately it is light which has the upper hand. It is a thought that I carry with me constantly.

The low, angled light has given shape and depth to the trees. It has also enriched the texture of the field.

A one-stop (0.3) neutral-density graduated filter has been positioned to darken only the sky.

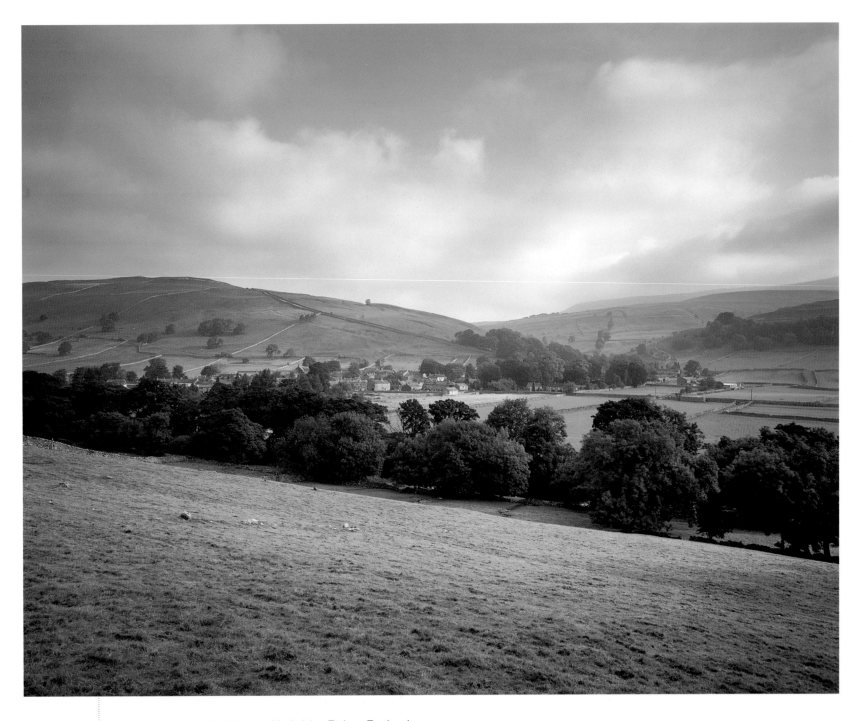

Kettlewell, Wharfedale, the Yorkshire Dales, England

CAMERA: Tachihara 5x4in
LENS: Super Angulon 90mm (Wideangle)
FILM: Fuji Provia 100
EXPOSURE: 1/2sec at f/27 (sometimes shown as f/22½)
WAITING FOR THE LIGHT: 1½ hours

Balanced Colour

I generally visit Cornwall three or four times a year, my preferred months being October, November, February and March. I avoid December and January because the short days are a little too short for my liking and April through to September can be challenging if your desire is to have unspoilt beaches to yourself (although photographing at dawn will normally give you your sought-after solitude – if you don't mind sharing it with seagulls and the occasional seal).

This early October picture of St Ives Bay was taken at sunset at the agreeably civilized time of 6.30pm. The photograph was pre-planned to the extent that I had consulted my tide timetable and had scheduled my week's visit to coincide with evening high tides. The combination of waves rolling in over a rocky beach against a backdrop of a colourful, twilight sky always holds potential and I ended each day by visiting a rugged part of the bay to watch the sun setting as the tide flowed in.

The week hadn't started well: a relentless blanket of grey cloud hovered above the ocean, which resulted in an insipid, colourless sky. I needed colour to draw the eye into the picture and then on towards the horizon. Fortunately, the weather gradually improved and finally, on my fourth attempt, I was in luck. The conditions were perfect because the sky was clear except for some distant hazy cloud. This allowed an orange glow to develop several minutes after the sun had set (this often happens in the right conditions, so don't leave too soon – you might miss the best moment). The warm colour of the sky contrasted well with the blue/grey of the foreground rocks and this is the essential element. The colours have brought a balanced structure to the image but they do not dominate, or distract from, the main subject.

The key to this photograph is allowing the various elements to make an equal contribution. Too much colour would have led the eye away from the foreground and middle distance, while too little would have produced an image that was flat and uninspiring.

The upper portion of the image has been strengthened by the warmth of the sky and balances the strong foreground.

A one-stop (0.3) neutral-density graduated filter has prevented the sky from being overexposed.

The long exposure has softened the motion of the waves and given the foreground rocks an ethereal quality.

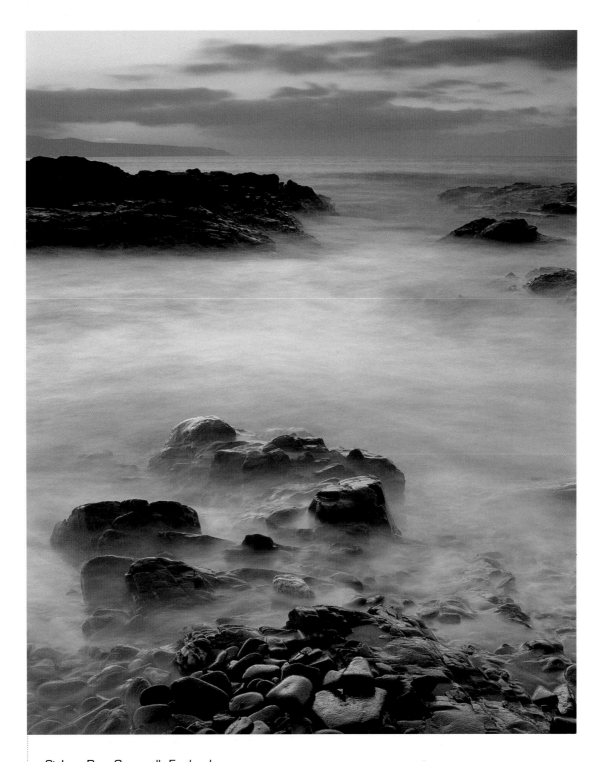

St Ives Bay, Cornwall, England

CAMERA: Mamiya RB67
LENS: Mamiya 50mm (Wideangle)
FILM: Fuji Provia 100
EXPOSURE: 6 seconds at f/32
WAITING FOR THE LIGHT: 30 minutes

Creating Simple Form

The sight of a blossoming English orchard in full bloom is a joy to behold. This tiny field was not, as you might imagine, hidden away in the hinterlands but was adjacent to a busy road south of Leominster. It shone like a beacon as I approached and I was compelled to stop and take a closer look.

The field was awash with colour. It was, in fact, overwhelming and there would have been too much information for the viewer to make sense of if it had been seen in its entirety as a photograph. To succeed, the picture had to be reduced to a simple form and, after considering various options, I decided to build the image around a single, central tree.

The orchard was much smaller than it appears here. I used a wideangle lens relatively close to the orchard to emphasize the foreground and this has had the effect of increasing the apparent length of the field. The background trees were considerably closer to the camera than they now appear, as was the tree in the middle of the picture. This 'stretching' of the field has created space, and with it simplicity. The mottled colours of the wild flowers fill the photograph and blend seamlessly with the trees. The image is completed by the trunk of the largest tree, which acts as the focal point and anchors the picture down.

The other feature I would like to comment upon is the presence of shadow. Normally I would tend to use diffuse light for this type of photograph, but in this case the absence of highlights caused the picture to look a little flat. I preferred the more vibrant appearance of the stronger light, and although it has created shadow, it is interesting to note that it is not distracting. This is possibly because the two main shaded areas are in similar positions on either side of the photograph; they therefore balance each other and make an equal contribution to the structure of the image.

The centrally positioned tree creates graphic symmetry.

The shadows provide a natural border and draw the eye towards the distant trees.

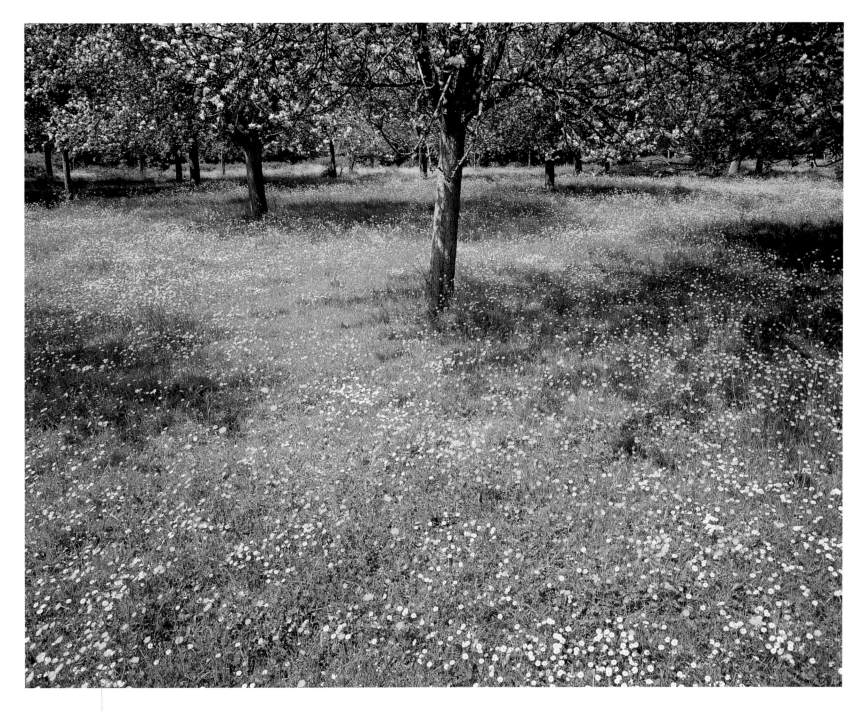

Near Much Cowarne, Herefordshire, England

CAMERA: Tachihara 5x4in
LENS: Super-Angulon 90mm (Wideangle)
FILM: Fuji Provia 100
EXPOSURE: 1 second at f/27 (sometimes shown as f/22½)
WAITING FOR THE LIGHT: 30 minutes

Land of the Midnight Sun

If you enjoy long summer days then Norway is the place to visit. The north of the country is the land of the midnight sun, where daylight prevails around the clock, while night-time in the more accessible south amounts to just two hours or so of semi-darkness.

I spent two weeks in the southern Aust Agder region in June, photographing at night and resting during the day. This was beneficial at the coast but inland the sun was often hidden by the towering mountainous terrain. This photograph of Flatebygd was taken at 8am, which was essentially the end of my working day. I would have preferred to have photographed the town earlier when the light would have been softer, but the sun was too low and much of the valley was in shade.

In order to depict shape and depth I have attempted to use passing cloud to create tonal variations across the valley, but this has been only marginally successful. While the shaded areas have given the

picture an added dimension, the contrast between highlight and shadow is, in some parts of the image, a little severe. Rather than being grey, the shadow in some areas is black, which is intrusive. The problem is partly caused by the pine forest that overlooks the town. Dark green is a remarkably efficient light-absorbing colour and anything but the softest shadow will often transform the green to black. With hindsight I should have waited for the forest to be more brightly lit but at the time the shaded areas did not seem to be as harsh as they now appear.

There is, however, a useful lesson to be learned from this, and it is that the contrast recorded by transparency film is always greater than the contrast seen by the eye.

Patches of sunlight would have improved the appearance of the forest.

The shaded foreground helps to define the contour of the land.

A one-stop (0.3) neutral-density graduated filter has prevented the sky from overexposing.

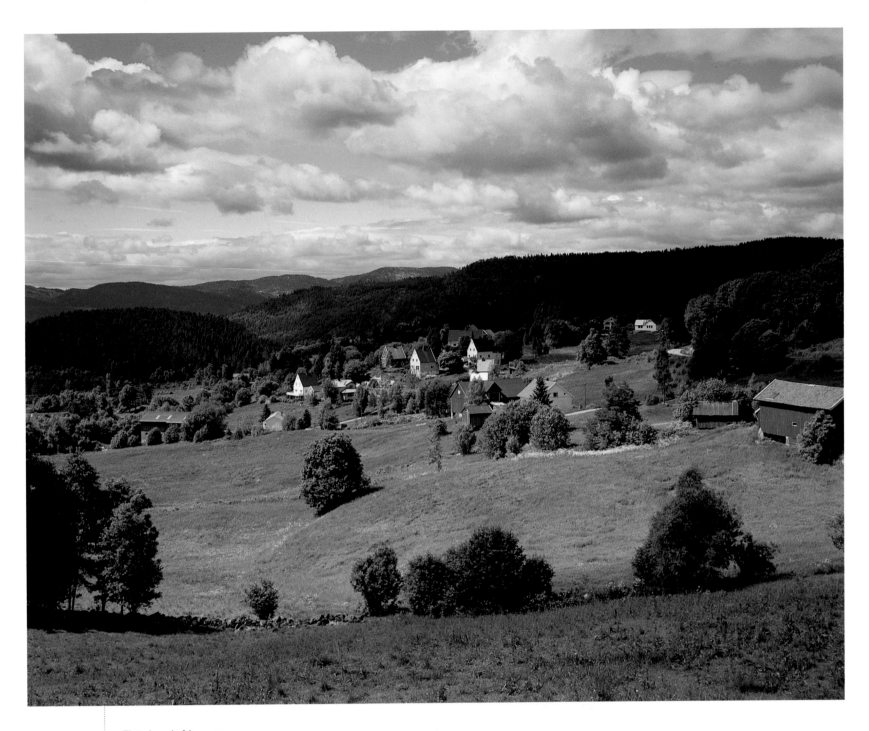

Flatebygd, Norway

CAMERA: Tachihara 5x4in
LENS: Super-Angulon 90mm (Wideangle)
FILM: Fuji Provia 100
EXPOSURE: 1/8sec at f/22
WAITING FOR THE LIGHT: 40 minutes

The Final Moment

I was nearing the end of a two-week visit to the south of France. It was late summer and the weather had been consistently fine. It had, in fact, been too fine because there had been scarcely a cloud in the sky. This might suit sun-worshippers but it is not the conditions under which the landscape photographer can thrive.

The only solution is to photograph in the very early or late hours of the day, when the sun will be casting long shadows over the landscape. This will create shape and depth, which would be lacking in a cloudless sky at other times of day. If the sky was clear then I would minimize its presence and restrict it to a fairly small strip at the top of the picture.

I arrived at the Verdon Gorges early one morning and waited for the sun to rise. My heart sank as it did so because I could see that it wasn't going to show the canyon at its best. The sun was in an unfavourable position but, fortunately, all was not lost because I realized that the aspect of the view was tailor-made for evening light. I returned later that day in hopeful anticipation, and I wasn't disappointed with what greeted me.

The obliquely angled light was penetrating the length of the canyon and was picking up every detail of its craggy surface. There was, however, a high degree of contrast, so I waited for the light to lose its intensity. As the weakening sun sank lower and lower, shadows began to creep up the canyon walls. A transformation took place as the grey landscape took on a golden hue and the blue sky began to glow in a combination of yellow, pink and purple. I waited until the last possible moment as the final seconds of sunlight flickered across the peaks of the canyon and then made four exposures in quick succession.

Darkness descended minutes later. It had been a hot and tiring fifteen hours since dawn but I had something to show for it. Tomorrow was going to be another fine day – and I would be spending it by the pool.

The sidelighting emphasizes the rugged surface of the canyon.

A glimpse of the winding river imparts a sense of scale and helps to accentuate distance.

The light has softened sufficiently to allow detail to be retained in both highlights and shadows.

An 81B warm-up filter and two-stop (0.6) neutral-density graduated filter combine to enrich colour and prevent the sky from being overexposed.

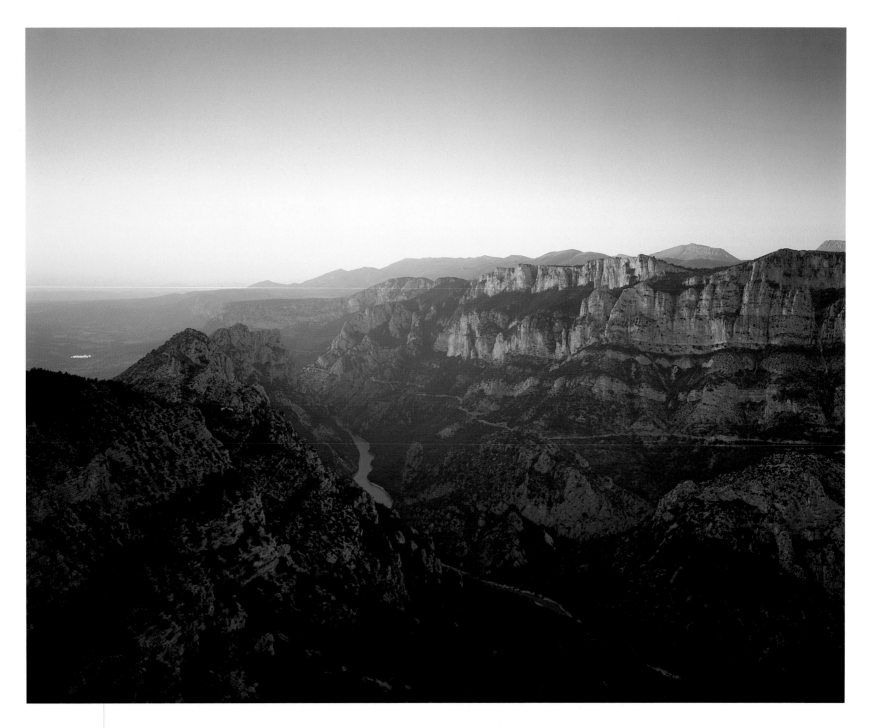

Les Gorges du Verdon, Provence, France

CAMERA: Tachihara 5x4in
LENS: Super Angulon 90mm (Wideangle)
FILM: Fuji Provia 100
EXPOSURE: 1 second at f/22
WAITING FOR THE LIGHT: 1 day

An Enduring Image

This weathered promenade has both a richly textured surface and strong, saturated colour. This posed a dilemma because they are both attractive qualities and would each make a contribution to the picture but they have very different lighting requirements. The bold colours would benefit from flat lighting while the irregular walls required directional sidelighting to highlight their coarse texture. I couldn't have both, so I had to make a choice.

The sky was partly cloudy and I was therefore able to assess the promenade in both sunlight and shade. Ultimately it was an easy decision to make. I much preferred the flat, diffuse light because the subtle details and colour variations were so much more prominent when softly lit. I also considered the steps and railings, which act as a focal point and draw the eye into the picture. Their distinct form enables them to stand alone without the need for highlights and shadows.

I considered using a polarizer but on this occasion its main effect was to increase contrast (this is sometimes an unwelcome property of this filter) so I abandoned the idea. I also decided that the picture didn't need warming because the sand was acting as a huge golden reflecting surface. The photograph was therefore taken with no added filtration, which is always pleasing.

I recently saw a painting of this promenade. It was dated 1904. When I compared it with my photograph, which was taken exactly one hundred years later, its appearance was virtually identical. Imagine that, a hundred years of exposure to the fury of the sea (by my calculation, for those interested in such matters, that's approximately 70,000 high tides) and there is no discernible erosion. I wonder if my photograph will endure the passing of time with similar success?

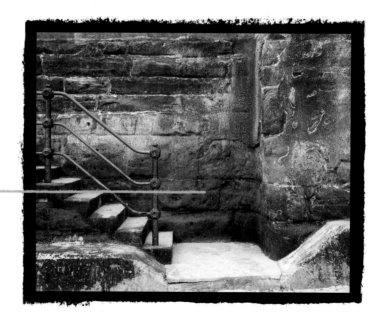

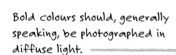

Bold colours should, generally speaking, be photographed in diffuse light.

Egremont Promenade, the Wirral, Merseyside, England

CAMERA: Tachihara 5x4in
LENS: Super-Angulon 150mm (Standard)
FILM: Fuji Provia 100
EXPOSURE: 1/2sec at f/22
WAITING FOR THE LIGHT: 15 minutes

The Play of Light

South of Leadville, the road to Aspen crosses the Continental Divide via Independence Pass. Reaching a height of 12,000ft (3,658m), this is not a journey for the faint hearted. The views from the summits are, you can imagine, breathtaking but it was the lower elevations that I preferred.

The small town of Twin Lakes shelters along the eastern side of the Pass. The aptly named town lies adjacent to two lakes at the foot of Mt Elbert, Colorado's highest mountain. The open aspect of the valley that surrounds the town gives an unsurpassed view of this spectacular area. I will always remember rounding a bend in the road and being presented with this marvellous image. It was the barn that first caught my attention; I knew that if I could construct the elements around the building then I would have a photograph.

After a little searching ('little' being forty-five minutes to be precise) I decided on the arrangement you see here. I wasn't totally happy with the foreground, so I subdued it as much as possible. The play of light

was the key to this. It was very windy (hence the photograph being taken in medium format and not with my wind-susceptible large-format camera) so it was a matter of waiting for the passing clouds to come rolling to my assistance.

After half an hour or so I had, briefly, the conditions I wanted; a shaded foreground, a brightly lit barn, patchy light on the mountains (which helps to delineate their rugged features) and an attractive sky. I managed just three exposures before the light deteriorated. Thankfully that was sufficient, and I am very happy with the result.

This was not a pre-planned photograph and I was fortunate to arrive at the time I did. To me this picture captures the spirit of Colorado and I will be eternally grateful for being in the right place at the perfect moment.

The barn is the key element because it gives depth and scale to the image. It is positioned at the meeting point of three converging lines which have been formed by the fenced river and the sloping mountains on either side of the building. The presence of these lines is subliminal but they play a crucial role in leading the eye to the barn. The structure of the picture has been built around this point of convergence because without it the photograph would have been dominated by the foreground bushes.

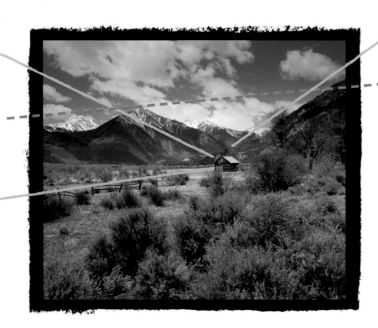

A one-stop (0.3) neutral-density graduated filter allows detail to be recorded in the highlights of the sky.

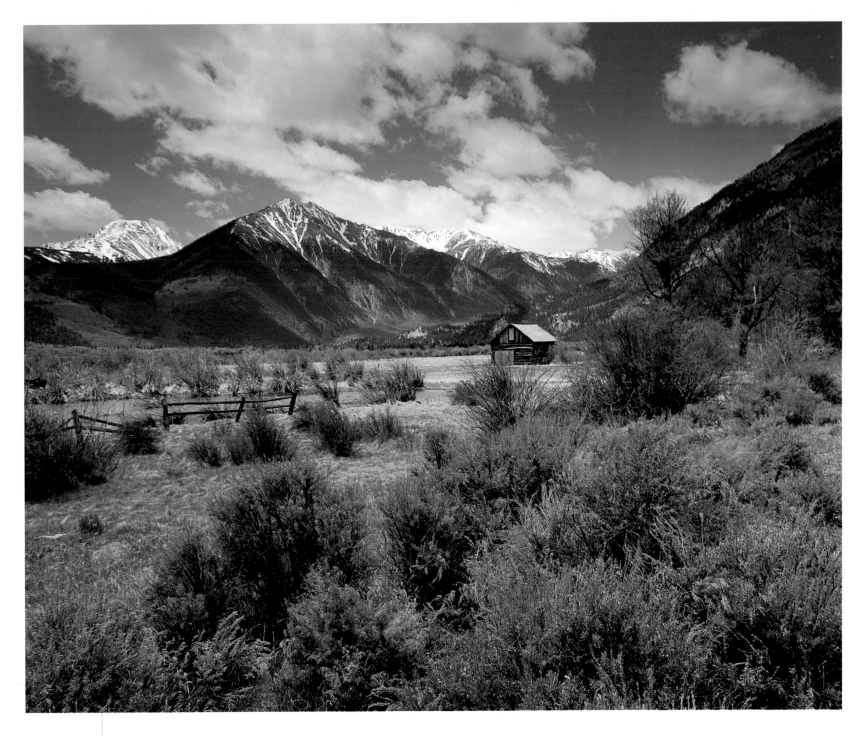

Twin Lakes, Colorado, USA

CAMERA: Mamiya RB67
LENS: Mamiya 50mm (Wideangle)
FILM: Fuji Provia 100
EXPOSURE: 1/15sec at f/32
WAITING FOR THE LIGHT: 30 minutes

The Colours of the Landscape

The landscape of County Mayo is as varied as any I have seen. In addition to the topographical variety, there are, of course, the colourful buildings for which the west of Ireland is quite rightly renowned. This can be a bonus if the weather is poor because this type of subject photographs well in overcast light. Having said that, I have always been fortunate when visiting Ireland and have enjoyed many spells of fine weather.

The old barn pictured here lies adjacent to Lough Beltra. It has obviously seen better days but, like many rural buildings, it is being allowed to age gracefully with the help of some occasional loving care and attention. I think it is now used as a fisherman's hut.

I was drawn to the building because of those solid blocks of softly muted, but striking, colours. There is also a strong graphic quality to the photograph because of the restricted colour range and the distinct, simple shapes. I waited for the clouds to soften the light and made three exposures. I used a polarizer to suppress reflections on the wooden surfaces. This has given a matt finish to the painted wood, which has further strengthened the colour.

I have to admit that I have a weakness for colour, but not just any colour; it is the colours of the landscape that attract me. More specifically, it is the weathered, man-made colours that reveal man's role in the care and maintenance of the landscape, which I find so alluring. Give me a lavishly painted barn and I'm happy.

I generally prefer to photograph this type of subject with a polarizing filter in soft, diffuse light. Invariably, this will lead to fairly long exposures, but this is not a problem. Indeed, I think there is something deeply satisfying about allowing a high-quality, fine-grain film to slowly soak up and absorb every last drop of colour. It is, after all, as close to painting with light as we can get.

Beware of capturing your reflection when photographing in front of a window.

A polarizer (fully polarized) has suppressed reflections on the damp surface of the barn and also strengthened colour.

A colourful theme can be effectively expressed by the use of simple shapes.

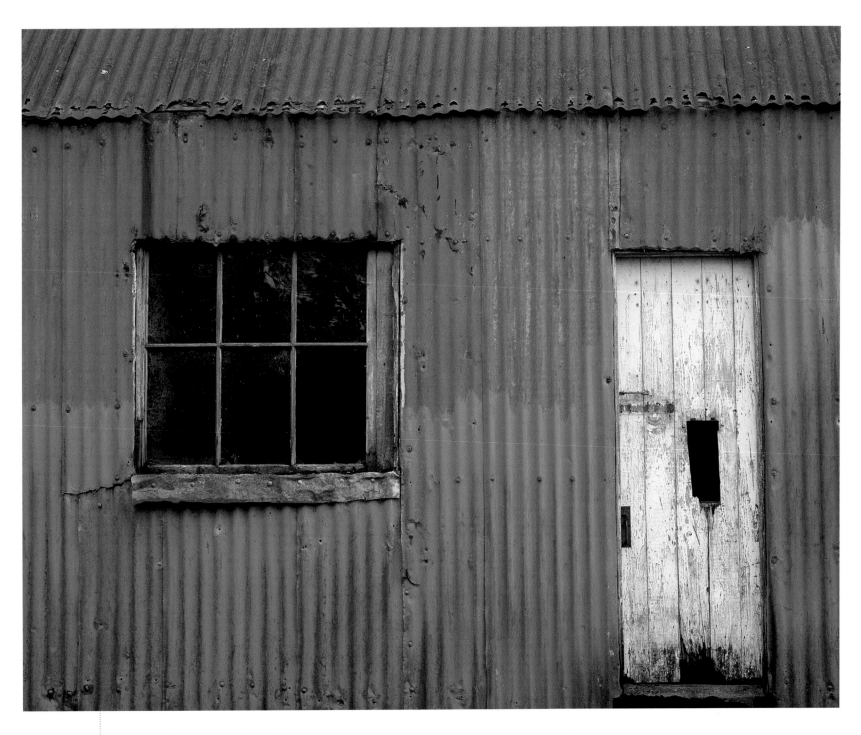

Lough Beltra, County Mayo, Eire

CAMERA: Tachihara 5x4in
LENS: Super Angulon 150mm (Standard)
FILM: Fuji Provia 100
EXPOSURE: 3 seconds at f/32
WAITING FOR THE LIGHT: 15 minutes

A Splash of Light

I had come to New England for the colour and colour is what I got, so I shouldn't complain. But there was no escaping it; even the sky was a deep, vibrant blue. It was colour overload and I felt an urge to dilute it. Sometimes seasonal characteristics are best expressed in muted tones, and I jumped for joy when I spotted this lovely combination of subtle hues.

As I studied the subject more closely, I had no doubt that it would make a fine picture. The only question was, do I photograph it in flat light or do I allow the sunlight to filter through the overhanging tree branches? Normally I would use flat, shadowless light but I liked the effect of the sun breaking through the leafy canopy. It, too, was subtle and this seemed to reinforce the theme of the picture.

I was concerned that the contrast might be a little severe, as it would have led to a loss of detail in either the highlights or the shaded areas. I took a Polaroid, which indicated that the contrast, although noticeable, was within acceptable limits. You can never be completely sure when assessing contrast from a Polaroid image because transparency film has slightly reduced exposure latitude and will therefore be less tolerant of a wide range of exposure values. However, I was fairly confident that it would be satisfactory and decided to proceed with the dappled light.

I am very happy with the result. This is one of those images which, to my mind, epitomizes the rural character of New England in a very simple but effective way. It is by no means a spectacular photograph but this, I think, is part of its appeal, which I find enduring.

When vertical or horizontal lines are present, take care to ensure that they are parallel with the picture edge. A Polaroid is a useful means of checking this if you are using a medium- or large-format camera. Alternatively, some 35mm and digital SLRs, plus some medium- and large-format cameras, offer gridlines on their focusing screens as a compositional aid.

Detail has been retained at both extremes of exposure value, despite the presence of direct sunlight.

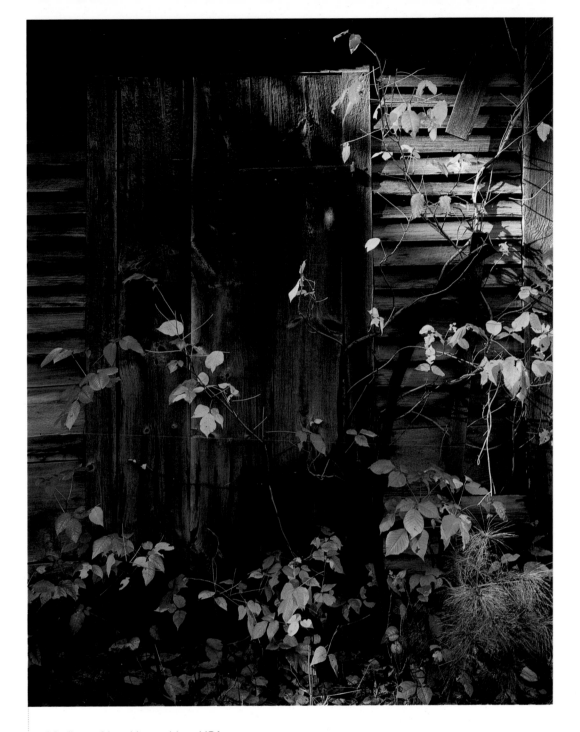

Madison, New Hampshire, USA

CAMERA: Tachihara 5x4in
LENS: Super-Angulon 150mm (Standard)
FILM: Fuji Provia 100
EXPOSURE: 1 second at f/32
WAITING FOR THE LIGHT: 20 minutes

The Back-lit Landscape

You might be surprised to learn that this picture was taken at 10.30 in the evening. This is the reality of photographing in Norway during mid-summer. There is just a relatively short period in the late evening and early morning when the light becomes discriminating in its illumination of the landscape. Because of this, my working days tended to start at 8pm and continue through to 8 or 9 the following morning, with a break during the brief period of darkness.

When I first discovered this tree-lined lake, the forest-clad mountain in the background was completely bathed in sunlight. Although the view was attractive, the brightly lit landscape produced no distinctive features which could be used as a focal point. Fortunately all was not lost, because the lake was back-lit. I watched as the sun sank towards the horizon, which caused long shadows to creep relentlessly up the face of the mountain. The low, directional light continued to transform the appearance of the landscape and the trees along the lake's perimeter were soon spot-lit against the darkening background.

I waited in the hope that the lengthening shadows would eventually cover the foreground. Ideally the group of trees should have been the only highlighted area but, regrettably, this didn't materialize. The shadows were beginning to engulf the trees and had I waited any longer the photograph would have consisted of a patch of brightly lit grass and not much else! I am, however, not dissatisfied with the picture. I still find it attractive but I know that had there been a subdued foreground it would have been a better photograph.

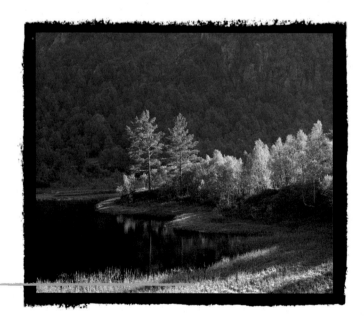

A shaded foreground would have improved the picture. Ideally the only highlight should be the group of back-lit trees.

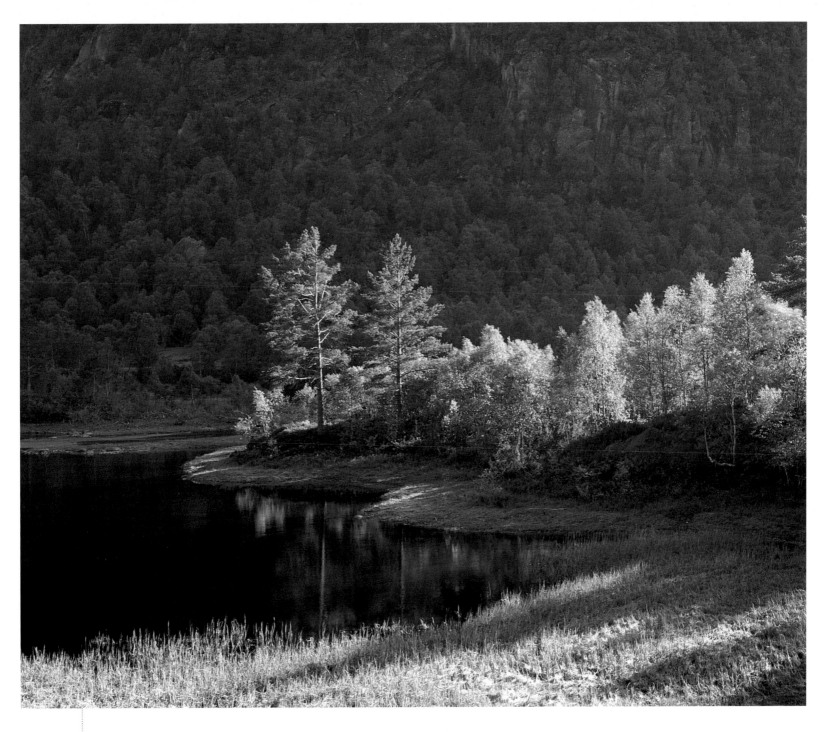

South of Aseral, Norway

CAMERA: Mamiya RB67
LENS: Mamiya 90mm (Standard)
FILM: Fuji Provia 100
EXPOSURE: 1/4sec at f/22
WAITING FOR THE LIGHT: 1 hour

The Effect of Colour

Compare this photograph with the picture on page 69 and you will see they are of a very similar structure. At a glance, they are both contemporary-style coastal images which share the same basic elements of land, water and sky. Their composition, however, is where the similarity ends because, fundamentally, they are quite different photographs.

The picture of Porlock Bay has a tranquil, empyreal quality. It is thought-provoking and has an inner depth that isn't present in the photograph here. This picture of Hoylake has a brighter, more buoyant atmosphere, which is a result of the bold colour and strong light. In terms of mood, the images are as far apart as two photographs can be.

The point of this is that composition will always be subordinate to light and colour. This is because brightly lit and vivid colours attract the eye and will therefore obscure the subtleties of a picture's structure. Soft, muted tones, however, are not as dominant and will allow a picture's finer qualities to reveal themselves.

Consider, therefore, the photograph as a whole. Study every aspect of it and determine your priorities. What is the theme of the picture? What do you want it to communicate to the viewer? If your objective is to create a bold, dynamic image then it would be appropriate to use bold, dynamic colours. A quieter, more reflective picture would, on the other hand, benefit from the presence of subdued hues of a restricted tonal range.

The light you use and the colours you choose are very powerful elements and this can work both for and against you. Harness this power correctly and you will have a potent tool that can bring a distinctive quality to your photography.

A polarizing filter (fully polarized) has darkened both the sky and water, which has strengthened the colourful theme and increased the contrast with the strip of sand.

Hoylake, the Wirral Peninsula, England

CAMERA: Mamiya RB67
LENS: Mamiya 50mm (Wideangle)
FILM: Fuji Provia 100
EXPOSURE: 1/4sec at f/22
WAITING FOR THE LIGHT: 1 hour

A Note from New England

Maine, October 8th

4pm

As I write this I am perched, rather uncomfortably, on a rock in a wooded area surrounded by a sea of rich, vibrant colour. This is my first trip to this part of America and I thought I knew what to expect. I had researched the area and studied photographs but, as I gaze across the landscape, the colour is overwhelming. It is literally everywhere and has to be seen to be believed.

I realize that I am, of course, tempting fate by making these notes. It is always safer to write about a photograph after, rather than before, it has been taken, but I'm feeling confident. This, I think, is the effect a New England fall has on a photographer; most of the work is done for you and it becomes difficult to take a bad picture.

At the moment I am waiting for the light to soften. Ideally I would like it to be semi-diffuse, i.e. flat but with a hint of highlight and shadow. This will, I hope, bring a sparkle to the picture without detracting from the vibrant saturation of the foliage. The sky here is cloudless, which I gather is not unusual, and this can present difficulties. In such conditions I generally avoid photographing in the middle of the day because the light is then usually too harsh.

5pm

Now, one hour later, the sun is beginning its descent. The light is weakening and becoming dappled as the surrounding trees cast their shadows across the field. Some cloud has formed, which may also help to diffuse the light. Time, I think, to set up my camera.

5.30pm

It is now 5.30pm and the photograph has been taken. The light was a little stronger than I would have preferred but unfortunately I had no choice: shadows were beginning to creep towards the barn and their presence would have exacerbated the problem. I am not, however, unduly concerned, and am hopeful that overall the tonal range and contrast will be acceptable.

Darkness is now beginning to descend. The time is approaching 6pm and that's it for today. The temperature is falling rapidly; it could be an early – and frosty – start tomorrow. I must say I look forward to it.

The polarizer has darkened the blue sky. It has also enriched the colour of the autumn foliage.

Lengthening shadows dictated the timing of the photograph.

Polarizer (fully polarized)

Weaker sunlight would have reduced the contrast but the exposure range is fortunately within acceptable limits.

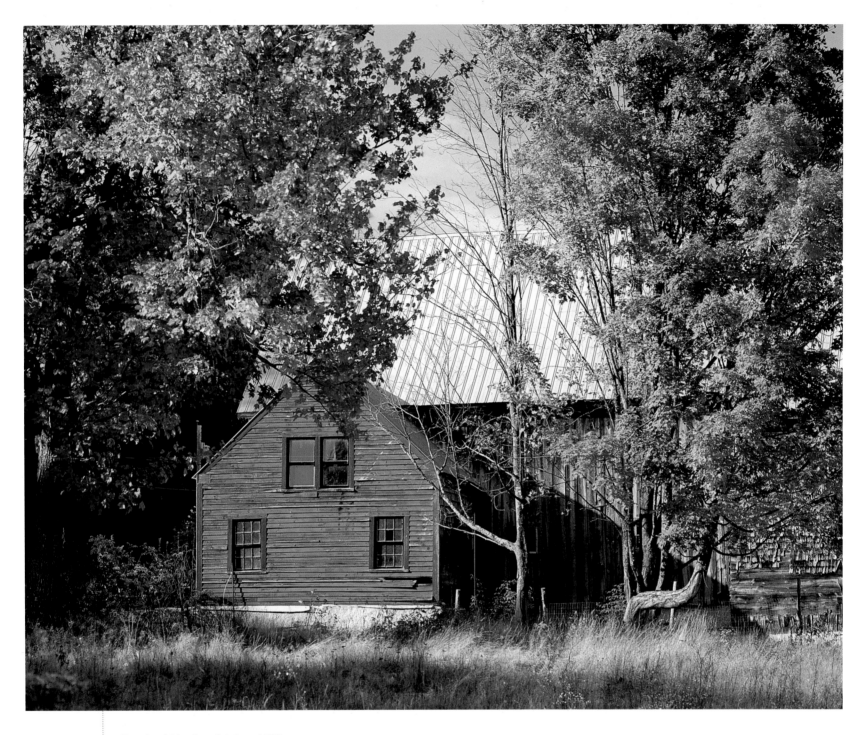

South of Naples, Maine, USA

CAMERA: Mamiya RB67
LENS: Mamiya 300mm (Telephoto)
FILM: Fuji Provia 100
EXPOSURE: 1 second at f/19 (sometimes shown as f/16½)
WAITING FOR THE LIGHT: 2 hours

A Typical Day

Maine is certainly a colourful state, albeit perhaps for just a few short weeks of the year. However, colour of a more permanent kind can be found along its extensive coastline. There is also a myriad of islands to be discovered and I have so far barely scratched the surface; perhaps I will return at another time of year and devote more attention to the many attractions the area has to offer. Boat trips are necessary to make a thorough exploration but I am sure there would be gems to be unearthed in the coves and inlets. One for the future I think.

The rock face pictured here is on one of the more accessible islands. Cousins Island is located to the north of Portland and is connected to the mainland by a short bridge. Fortunately my visit coincided with low tide and I was able to explore its shoreline fully.

I liked this rock because of its autumnal colours and, as it was the middle of October, it seemed appropriate to continue with the autumnal theme. At the time I was preparing to take the photograph bright sunlight was shining from a cloudless sky. Colour and texture are best depicted using flat light, so I spent the next thirty minutes or so constructing an elaborate sun shield. It consisted of two aluminium cases supported by an inventive array of rocks and boulders. It took several attempts to balance the precarious load but eventually everything was rigidly in place. Then, at the very moment I was about to make my first exposure, cloud and sea mist suddenly descended. It produced the exact light I wanted! My efforts had been wasted, as my sun shield contraption was in an instant rendered superfluous. The light, as ever, had been predictably unpredictable and I could not have anticipated the sudden change in conditions. It was, of course, just another typical day on the landscape.

An 81B warm-up filter was used to compensate for a bluish cast, which is often prevalent in coastal areas.

Polarizer (fully polarized)

The use of a polarizing filter has enriched the colour and texture of the surface of the rock.

Cousins Island, Maine, USA

CAMERA: Tachihara 5x4in
LENS: Super-Angulon 150mm (Standard)
FILM: Fuji Provia 100
EXPOSURE: 1 second at f/32
WAITING FOR THE LIGHT: 40 minutes

A Conveniently Remote Cottage

This was my second visit to Mull. My previous trip to the island had produced the grand total of just one picture (page 175). I had already exceeded that number (albeit by one) and it was looking promising. This time the weather was being more accommodating and the photograph of this remote cottage, which had previously eluded me, was now firmly in my sights.

The cottage isn't, in fact, quite as remote as you might imagine. It lies alongside the road that runs from the main ferry port at Craignure to the small village of Bunessan, where I was staying. The road, however, is mainly single track and traffic is, to say the least, light. Given the cottage's convenient location I had to embark on a surprisingly arduous climb, and then descend, before I found a position with which I was happy.

Because of the structure of the rocky foreground and the contour of the hillside and distant mountains, I decided to place the building in a horizontally central position. This enabled me to use the remains of the stone wall, which leads away from the foreground, as a path along which the eye can travel. This arrangement takes the viewer into the picture towards the cottage and then on to the mountains, whose peaks are also centrally located. The strong central theme is then supported on both sides by the inwardly sloping hills, which again lead the eye towards the middle of the picture.

I had tried various alternative arrangements, but this was the most successful because it shows the cottage in its wider environment. It also depicts the rugged nature of the island's landscape, which has been enhanced by the soft, but directional, light.

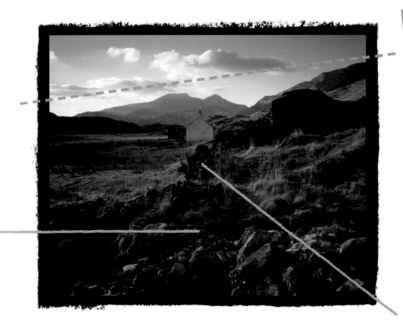

Light is the essential ingredient in this picture. It was the last light of the day and this was the only time the rugged nature of the landscape was depicted in such detail. At other times of day the light was either flat or created too much contrast.

A one-and-a-half stop (0.45) neutral-density graduated filter was needed to darken the sky and prevent the highlights from being overexposed.

Receding lines are an effective method of drawing the eye into the picture and creating a three-dimensional quality.

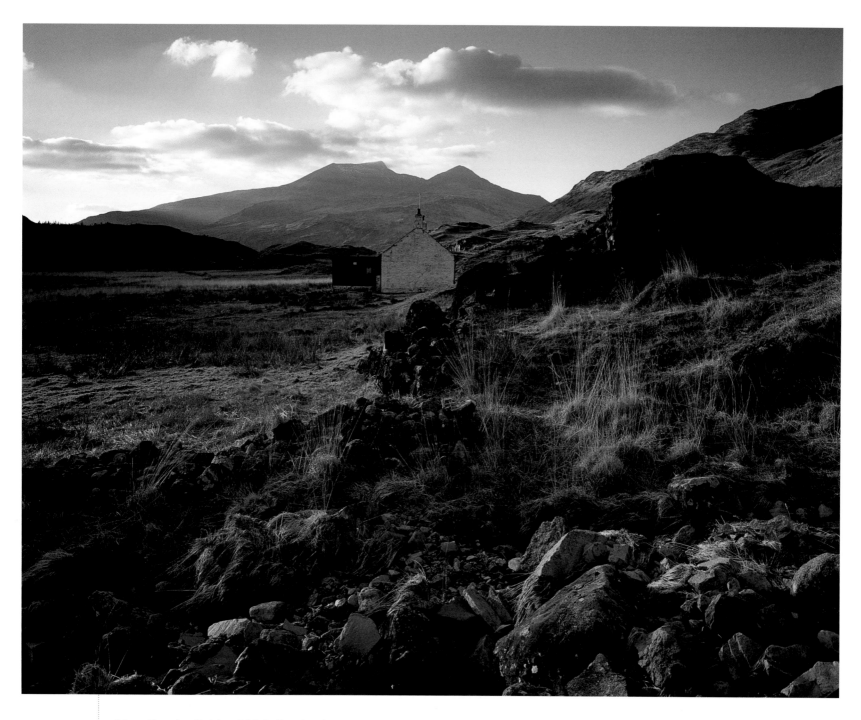

Near Strathcoil, Isle of Mull, Scotland

CAMERA: Tachihara 5x4in
LENS: Super Angulon 90mm (Wideangle)
FILM: Fuji Provia 100
EXPOSURE: 1 second at f/32
WAITING FOR THE LIGHT: 1 hour

A Caribbean Dawn

In the heyday of Cornwall's mining industry Portreath was an important and thriving port. Its glory days are now behind it but the character of the village has survived the passing of time. The charming arrangement you see here is part of a row of old and unspoilt terraced cottages that overlooks the harbour at the centre of the small community.

I knocked on the door of the cottage and requested permission to photograph the steps. I was particularly attracted by the striking colour of the painted handrail and asked the owner of the property if she knew the name of it, but unfortunately she didn't. Rain was threatening, so I wasted no time in taking the photograph. It was relatively straightforward but I had to position my camera carefully to ensure that my reflection did not appear in the window. It might not be particularly noticeable at the time the picture is taken, but it would be painfully obvious afterwards.

As I was preparing to leave, the elderly lady reappeared with a tin of paint raised triumphantly in the air. 'Caribbean Dawn!' she exclaimed. It wasn't what I was expecting, well not at 11 o'clock on a cold November morning on the west coast of Cornwall! Shortly afterwards, the rain began to fall and the Caribbean dawn took on a decidedly English appearance.

Footnote: A couple of weeks later I'm back at home looking at this picture on my lightbox, admiring my work and generally feeling pleased with myself. My younger (non-photographer) daughter enters the room and looks over my shoulder. 'That's quite good' she pronounces 'but wouldn't it have been better if you'd raised the camera slightly so you could have had an unbroken view of the window?'

My ego came crashing back to earth. She was, of course, absolutely right. My judgement had been impaired by my enthusiasm to capture the image and I missed this obvious detail. I switched off my lightbox and retired for the evening.

Polarizer (fully polarized)

A polarizer will reduce reflections in a window.

I decided to allow the weeds to remain in view. At the time I thought they would soften the rigid lines of the image but they are slightly distracting. The photograph would, I think, have benefited from their removal.

Carelessly I allowed the window and handrail to overlap. Ideally there should be a gap between them.

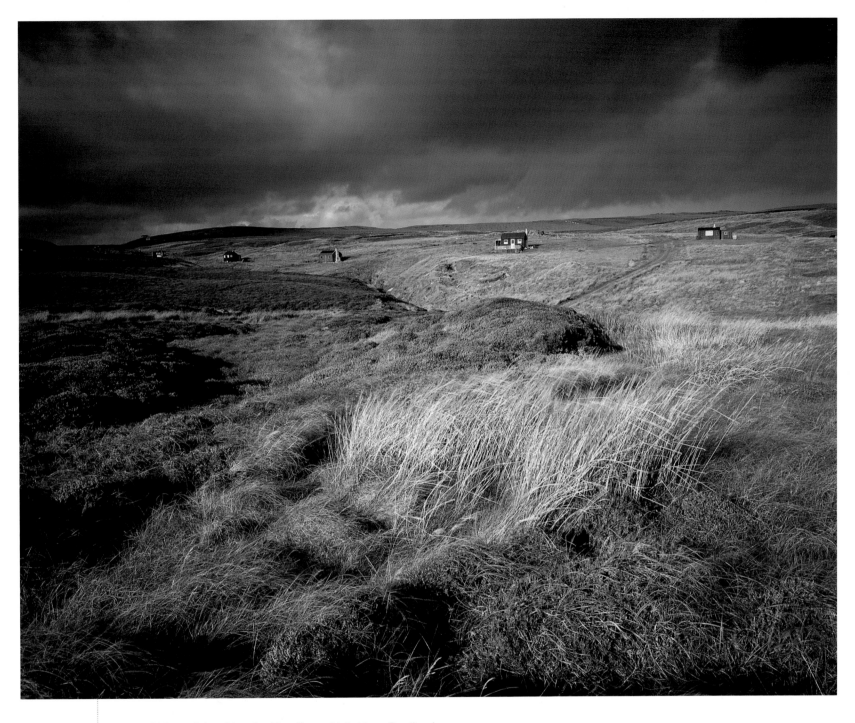

Port of Ness, Isle of Lewis, The Outer Hebrides, Scotland

CAMERA: Tachihara 5x4in
LENS: Super-Angulon 90mm (Wideangle)
FILM: Fuji Provia 100
EXPOSURE: 1/2sec at f/32
WAITING FOR THE LIGHT: 5 hours

An Original Perspective

Since its regeneration several years ago the Albert Dock in Liverpool has attracted countless numbers of visitors and has, no doubt, also been photographed a countless number of times. Living relatively close to Liverpool, I often see pictures of the prestigious development. The docks are a fine example of historic architecture but the photographs all have a predictable familiarity. Having photographed the area some years earlier I had no desire to add to the plethora of standard images so, during a recent visit, I ignored the obvious and began to search for an original perspective.

It was a fine evening and the sinking sun was casting long shadows across the waterfront buildings. This accentuated the architectural detail which produced strong, graphic images but I was drawn towards the water's edge where the promenade overlooks the river in a westerly direction. A glint of dark metal had caught my eye; here, in all its simplicity, was the picture I had been seeking.

This is a photograph bereft of spectacular features but that, I think, is part of its appeal. The evening sunlight has brought a sparkle and a warmth to the image which has elevated the scene and transformed the ordinary into something most attractive. Light, of course, is the key element. The railings and promenade are merely props which play a secondary role.

Picture taken, I strolled back to my car some distance away. On the way I counted three photographers with their cameras trained on the illuminated buildings. I felt no urge to join them. The shining metal railings had formed a lasting impression in my mind and the floodlit docklands, impressive as they were, somehow seemed decidedly second best.

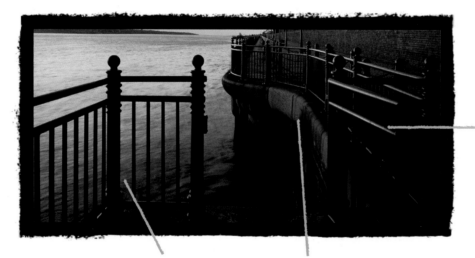

Light striking the railings draws the eye and creates a focal point. Without this there would have been no picture to take.

The panoramic format is perfectly suited to the shape of the railings. It simplifies the image by shutting out extraneous detail and therefore concentrating the viewer's eye on the theme of the picture, which is symmetrical repetition and light.

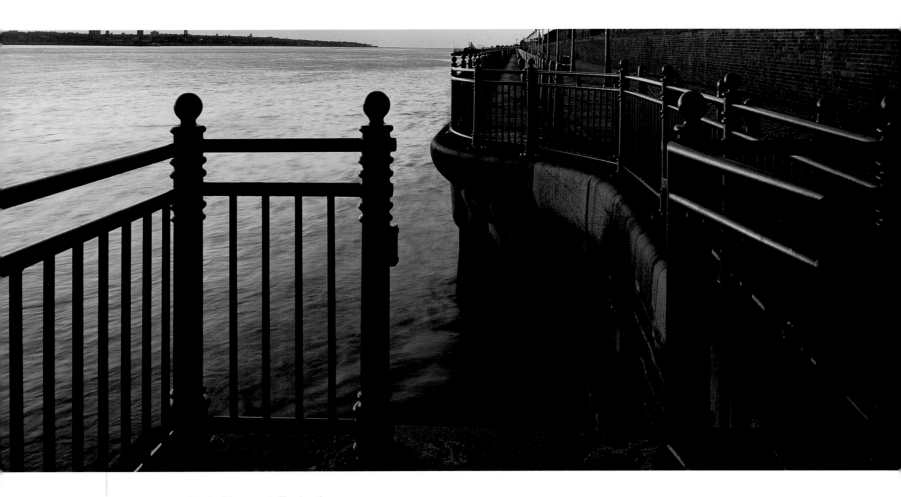

The Albert Dock, Liverpool, England

CAMERA: Tachihara 5x4in (12x6cm format back)
LENS: Super-Angulon 90mm (Wideangle)
FILM: Fuji Provia 100
EXPOSURE: 2 seconds at f/32
WAITING FOR THE LIGHT: 20 minutes

Using Light Effectively

Compare the sets of pictures below and opposite and you will see how the quality of light has a fundamental effect on the subject being photographed. Sometimes a picture will benefit from soft, diffuse light and sometimes it will require bright, directional light. Generally speaking, close-up images are best photographed under diffuse light and bigger views under stronger, directional light. However, there is no hard and fast rule to this and, in time, your experience will tell you what the best light is likely to be for a particular subject. This is something which you can practise and master on your own.

Begin by selecting a small number of different types of subject. First choose a close-up image which contains both colour and texture; for example a dilapidated door or an interesting tree bark. Then photograph it in both bright and hazy sunlight as well as soft, shadowless light from an overcast sky. The direction of the sunlight will, of course, also affect the appearance of the subject; therefore I suggest you make a number of exposures at different times of day, keeping a record of the time, lighting conditions and exposure.

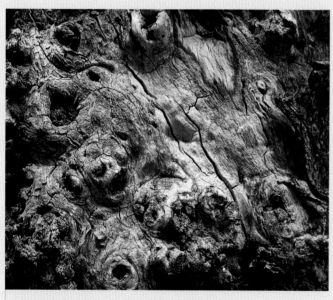

Near Montefegatesi, Tuscany, Italy
This first photograph was taken at midday in hazy sunlight. Despite the relatively soft light, the shadows are still intrusive; they interfere with the surface pattern and texture of the bark and bring an element of confusion to the image.

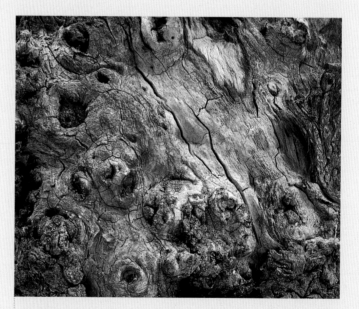

This second picture was taken much later in the day as the sun was setting. The light is much softer and also much warmer. Indeed, if anything it is a little too soft and warm. The ideal light would perhaps be somewhere in the middle, i.e. a hint of highlight and shadow with just a delicate warm tinge.

The same exercise should then be repeated with a mid-distance view, such as an isolated farmhouse or a group of trees. Don't worry at this stage about the aesthetic quality of your subject; the objective is solely to gain an appreciation of the effect the varying combinations of light, shade, contrast and tonal range can have on a photograph.

Finally, find a wide, open view, preferably one with a hilly or mountainous terrain. Again, photograph it at different times of day in flat light and in strong and hazy sunshine. Big views can

take on a multitude of appearances and I therefore recommend that you visit the same location a number of times and experience as many different lighting conditions as possible.

When assessing the results, look carefully at the components of each image. Decide what the key features are and judge how these elements have responded to the varying qualities of light. Repeat the exercises with other subjects and carefully compare all the images. If possible, return to some of the locations and try to improve on your earlier photographs. Over time your instincts will begin to tell you the type of light most appropriate for a given location.

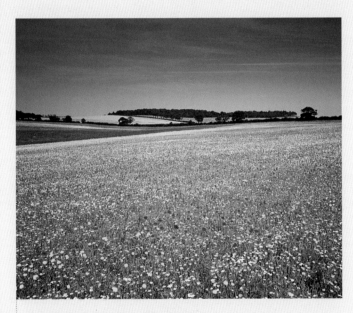

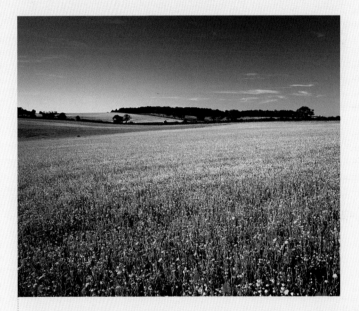

Ringstead, Norfolk, England
Again, hazy sunshine prevailed at the time this picture was taken. It was mid-summer and the sun was high overhead and as a result it produced fairly flat light. This was ideal, however, because here there is nothing to be gained from the presence of highlights or shaded areas. The neutral colour balance of the midday sun also suits the image perfectly.

This second photograph was taken in the evening, one hour before sunset, and it has suffered as a result. The light is now much too warm and the low-angled sunlight has created unwelcome areas of shadow which spoil the delicate structure of the expanse of flowers.

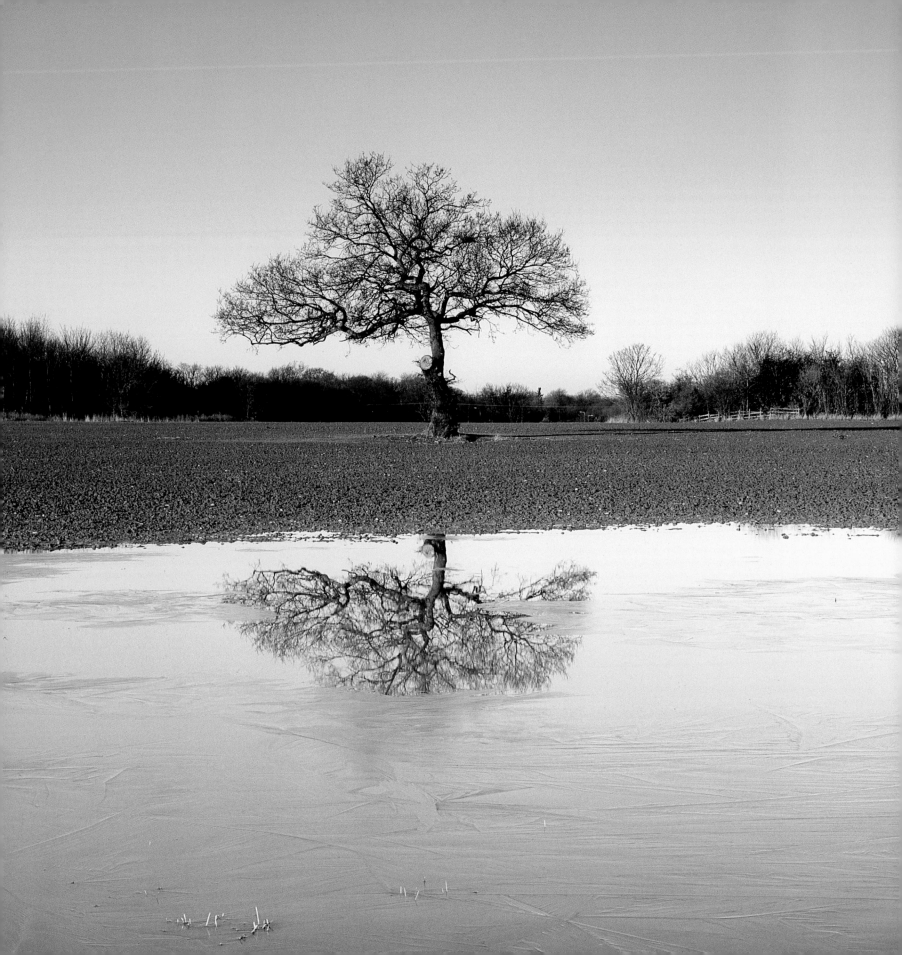

CHAPTER TWO

Landscape Elements

Landican, the Wirral,
Merseyside, England

This field is close to where I live and I monitor its appearance throughout the year. It was unusual to see it flooded, so I took the opportunity to capture the reflection of the isolated tree. The frozen water makes a contribution to the photograph but it is regrettable that the reflection has been impaired by the ice. I returned a few days later but the water had seeped away, leaving behind a rather unattractive quagmire.

CAMERA: Tachihara 5x4in
LENS: Super Angulon 90mm
(Wideangle)
FILTER: Polarizer (fully polarized)
FILM: Fuji Provia 100
EXPOSURE: 1/2sec at f/32
WAITING FOR THE LIGHT:
Immediate

It is sometimes magnificent, occasionally breathtaking and at times awe-inspiring, but rarely is the landscape perfect. This is, of course, a sweeping statement and perhaps I should qualify what I say, as I speak solely from the photographer's standpoint. We are consumers of nature. We feed on the raw material of landscape and, like any raw material, it is often flawed. To arrive at our finished product we must refine the material, assemble it and preserve it. We are working with the rudiments of landscape and it is the approach to this which, ultimately, determines the photographer's success or failure.

But the landscape is not entirely what it seems. On the surface its appearance has a predictable familiarity but beneath this there lies another layer. Delve into this layer and you will enter a world of shapes, patterns, colours and textures. These are the graphic elements which form the basis of every image. Observing these elements and using them imaginatively is, to my mind, the cornerstone of distinctive photography.

Seeing the landscape in this way can be a challenge and I still find that there are many occasions when a conscious effort must be made to look below the surface. It might not be easy but that is what makes the search so rewarding. Unlike my fictional namesake, nobody has ever said to me 'Photography? Elementary my dear Watson' – and long may that continue.

Compressed Perspective

From the Three Sisters viewpoint at Katoomba, Australia, the grandeur of the Blue Mountain range is breathtaking. The vista is one expansive sweep of shimmering peaks, which extends as far as the eye can see. It was certainly impressive and I was tempted to photograph the spectacle as a panorama, but I also had reservations. I was concerned that the imposing scale of the mountains would be lost when seen as a small two-dimensional image. It was time for thought. I breathed in the atmosphere and contemplated the scene.

I could see a break in the mountains where the stacked ridges receded towards the horizon and then blended imperceptibly with the darkening evening sky. There was a strong graphic quality to the elements here and they very effectively communicated the scale and magnitude of the mountain range. My deliberations were over.

I used a short telephoto lens and concentrated on a small area where the tonal contrast was relatively high and the descending blue mist most pronounced. I was fortunate to have right above this a splash of pink in the sky, as it brought a degree of necessary warmth to the picture.

I based exposure on the middle tones. Meter readings taken from the lightest and darkest points indicated a span of four stops which, with transparency film, produces an image of a wide, but acceptable, tonal range. It was therefore unnecessary to darken the sky with a graduated filter.

Progressively lighter tones, which step back into the distance, respond well to being photographed with a telephoto lens. The compressed perspective produced by using a telephoto lens at a distance has the effect of flattening the image but, paradoxically, it also emphasizes depth.

The pink strip brings warmth and contrasting colour to the image.

The combination of compressed perspective and misty, lightening tones emphasize distance very effectively.

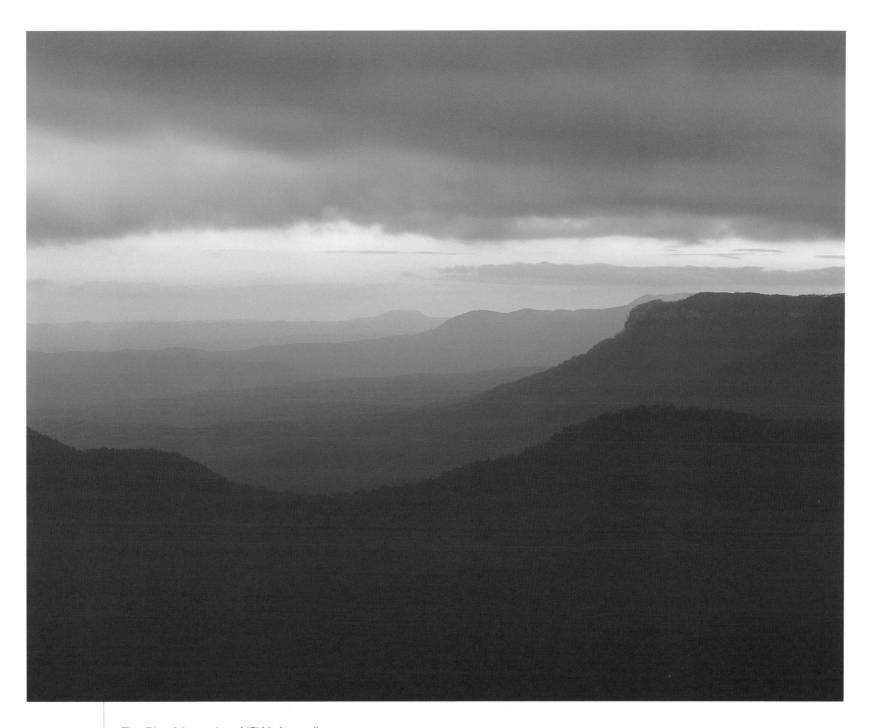

The Blue Mountains, NSW, Australia

CAMERA: Tachihara 5x4in
LENS: Fujinon 300mm (Short telephoto)
FILM: Fuji Provia 100
EXPOSURE: 5 seconds at f/22
WAITING FOR THE LIGHT: 10 minutes

A Bygone Age

Stand in front of Saltburn Pier and the thought that they don't build them like they used to is likely to come to mind. This is most certainly true in the case of the traditional British pier (in actual fact they no longer build piers at all) and those still in existence should, I believe, be preserved at all cost.

Saltburn Pier dates back to Victorian times, and it shows. Its iron trestle construction reveals its age and is redolent of a bygone era. It was originally built in 1867 and has, against all odds, survived a turbulent and often disastrous past. Now only half its original length (it was once hit by a passing ship, which is hardly surprising as at the time it extended a somewhat ambitious 1,400ft (427m) into the sea), the pier is still an impressive sight and retains the splendour of its glory days.

I wanted my photograph to emphasize both the pier's size and its imposing presence; the reflections on the wet sand provided me with the means to do just that. The vertical reflections effectively double the height of the pier and accentuate its dominance of the beach on which it stands. They also introduce a dramatic edge to the picture, which is compounded by the heavy threatening sky. It all adds up to a powerful and arresting image and one with which I am very satisfied.

What I also find interesting about this photograph is the fact that colour plays almost no part in it. The golden hue of the sand is incidental to the theme and structure of the picture and the image would work just as well in black & white. This is a little ironic because when I took the photograph I cleverly (or so I thought at the time) added a warm filter to boost the colour!

A one-stop (0.3) neutral-density graduated filter has reduced the brightness of the sky and has captured the attractive cloud structure. The dramatic mood of the picture is accentuated by this heavy cloud.

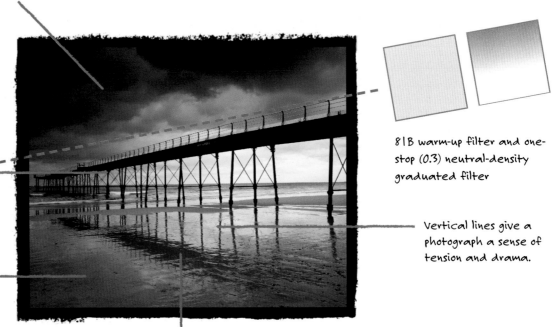

The wideangle lens has increased the apparent length of the pier and has emphasized the repetitive pattern of its supporting columns.

81B warm-up filter and one-stop (0.3) neutral-density graduated filter

An 81B warm-up filter has enhanced the colour of the sand but on this occasion it has brought no discernable improvement to the photograph.

Vertical lines give a photograph a sense of tension and drama.

The dark reflections give weight to the foreground and prevent the picture from becoming top heavy as a result of the imposing, stormy sky.

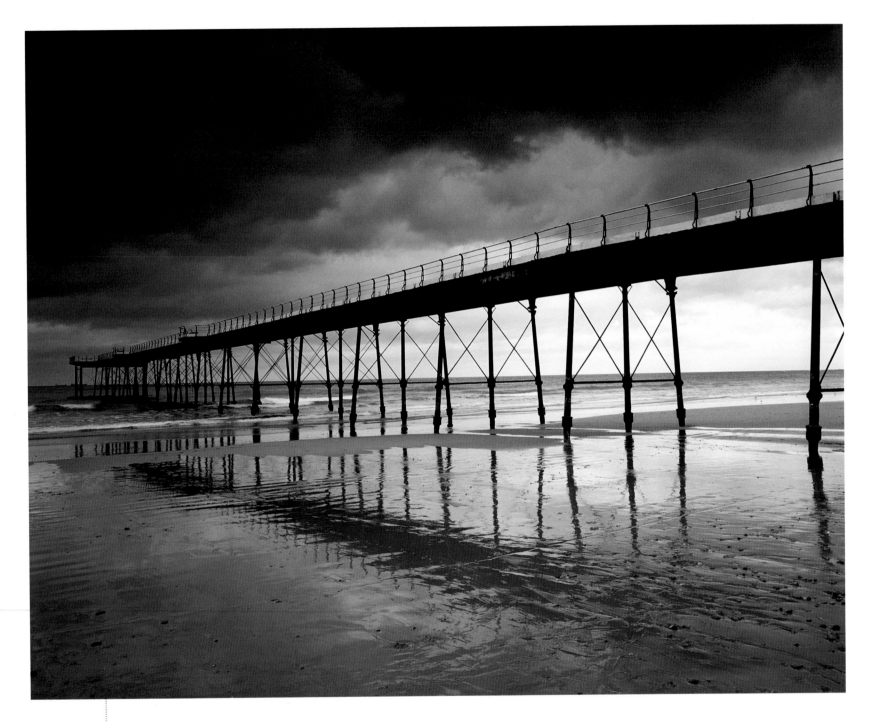

Saltburn Pier, North Yorkshire, England

CAMERA: Tachihara 5x4in
LENS: Super-Angulon 90mm (Wideangle)
FILM: Fuji Provia 100
EXPOSURE: 1/2sec at f/27 (sometimes shown as f/22½)
WAITING FOR THE LIGHT: 2 hours

A Loose Arrangement

Norway is a land of fjords, mountains, lakes and coastline; here there is everything a photographer could wish for. Over 1,610km (1,000mi.) long with a population of just 4.5 million, it is rural landscape on a grand scale. Indeed, the size of the country presents the visitor with a dilemma; it is too vast to see in its entirety in one trip and every region has its own attraction.

When I visit a country I prefer to concentrate on just one small area. I have found that this is the only way to ensure that I do justice to the places I am photographing. I like to be able to visit a location a number of times to ensure that I have seen and photographed it at its best. After some detailed research, I chose for this, my first trip to Norway, the Aust-Agder region in the south of the country. It is readily accessible and has a landscape rich in variety.

The tiny village of Nordbo typifies the region. Scattered farms and cottages mingle haphazardly with forests and hay meadows. This random approach to the use of the land reflects the low density of the population. Space is not at a premium here. Nothing needs to be formally arranged or organized. To the photographer, such randomness can be a source of inspiration but it can also be a challenge. There is an inclination to impose a sense of order on the landscape, which is natural; composition is, after all, a key element to the success of any picture. Sometimes, however, a degree of restraint should be exercised. The sought-after perfect composition may come at a price and might not be the ultimate priority.

There is a relaxed informality to the structure of the image. The photograph flows from the foreground through to the distant forest-clad hills but the sense of scale is, to a degree, compromised by the juxtaposition of the trees and buildings. A higher viewpoint would have helped in this respect but this would have weakened the foreground. Moving to the left or right also proved ineffective, so I therefore had no option but to accept what was before me. I am, however, quite satisfied with the outcome. Indeed, I rather think that the loose arrangement in the mid-distance captures the essence of the southern Norwegian landscape, and any photograph that achieves this should be considered a success.

The cloud structure helps to prevent the picture falling away to the left. The downward slope of the hill is balanced by the position of these clouds.

The colourful foreground benefits from soft lighting, while sunlight in the mid-distance brings life to the photograph and draws the viewer into the picture.

This is the perfect sky to be photographed with a polarizing filter (here fully polarized). The filter darkens the blue but leaves the clouds looking clean and white.

The two larger trees act as a frame and help to keep the viewer's attention within the borders of the picture.

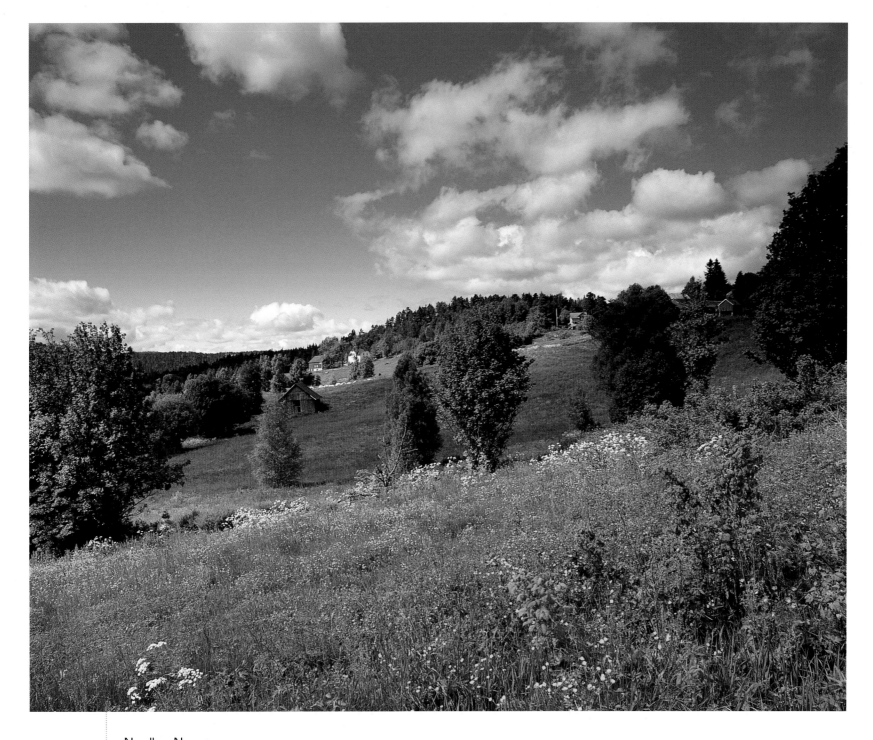

Nordbo, Norway

CAMERA: Mamiya RB67
LENS: Mamiya 50mm (Wideangle)
FILM: Fuji Provia 100
EXPOSURE: 1 second at f/32
WAITING FOR THE LIGHT: 40 minutes

An Added Dimension

This English wheat field is a most beguiling subject; the group of trees and the shapely green strip of grass crown the field quite marvellously, but this does not in itself produce a complete picture. This landscape consists essentially of a single element because there is no foreground or mid-distance as such. The sky therefore has an important contribution to make, particularly as it fills the majority of the photograph.

I was very fortunate to arrive at the field after a showery spell. The water vapour produced by the rainfall has created those wonderful, crisply defined cumulus clouds that sit so perfectly on top of the hill. The effect of this is that the clouds have become an extension of the landscape and have given it an alluring shape and roundness which, in reality, does not exist. An inferior sky would not have enhanced the landscape in this manner and the picture would almost certainly have lapsed into mediocrity.

Moments like this are uplifting. Such occasions – where nature does everything for you – feed the heart and mind of the hungry photographer. When you are handed something on a plate, grab it with both hands – it might be some time until the next feast arrives.

A combination of sun and showers are the conditions in which the landscape photographer can normally thrive. This type of weather produces a constantly changing light, which in turn gives the landscape an ever-changing appearance. This alone is a promising prospect but there is, in addition to this, something else. If the weather is predominantly fine, with just a light scattering of showers, then it is likely that massed ranks of cumulus clouds – those brilliant white puffy balls of cotton wool – will form low in the sky. This can bring an added dimension to the landscape.

The stray cloud detracts from the purity of the image. Ideally the sky should consist of a single group of clouds against an unbroken blue background.

The polarizer (fully polarized) has darkened the blue in the sky, which contrasts with and accentuates the shape and presence of the clouds.

The landscape is frontally lit (i.e. the sun was behind me), which is the perfect light. There are no subtle lighting effects required here. This is an image of crisp, clearly defined shapes and colours. The frontal lighting has also given the polarized sky an attractive tonal uniformity.

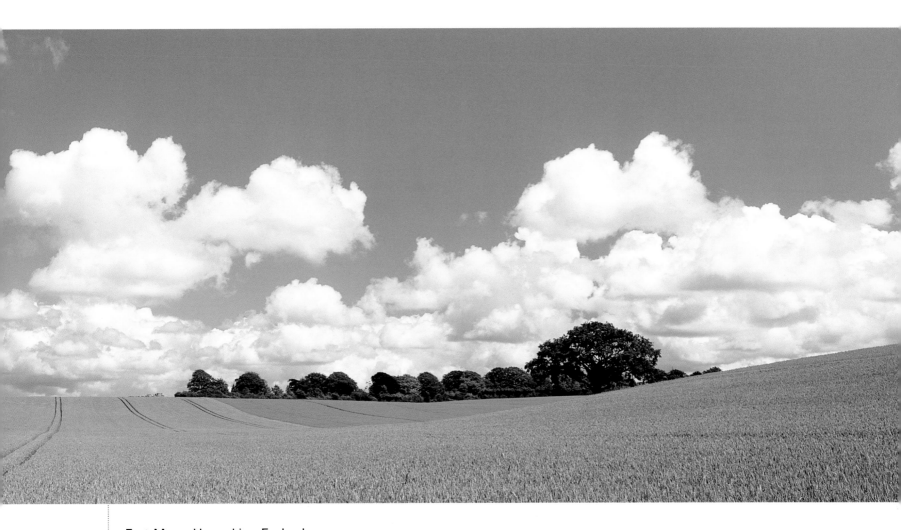

East Meon, Hampshire, England

CAMERA: Fuji GX617
LENS: Fujinon 105mm (Standard)
FILM: Fuji Provia 100
EXPOSURE: 1/2sec at f/32
WAITING FOR THE LIGHT: Immediate

A Symmetrical Theme

I was driving back to my accommodation in the Lake District and feeling a little sorry for myself, as the day had not been productive. I had stopped to check my bearings and noticed a fence that bordered open moorland a few yards ahead. It was in itself completely unremarkable, but behind it a waxing crescent moon had just made its grand appearance; together they were an arresting sight. Ironically, now that the light had faded I could see that my day was about to begin.

The moon is quite obviously the subject of this picture. The landscape plays no more than a supporting role and I therefore placed the moon in a dominant, central position. However, unless there is a strong symmetrical theme to the image, such an arrangement can look unsettling. Fortunately I was able to use the fence posts to reinforce the symmetry by placing them uniformly across the width of the picture. This, then, becomes a very simple, but effective, structure. It works because there is a surreal quality to the photograph, which has been created by imagery, not reality.

In this context the simplicity of the picture becomes its strength. The sky and the moorland are merely subordinate elements to the moon, which is supported by the repetitive row of fence posts.

In order for some detail to appear in the landscape I darkened the sky with a three-stop (0.9) neutral-density graduated filter and then based exposure on the land. My meter reading suggested a shutter speed of twelve seconds. However, the moon's movement across the sky is faster than it appears (it travels approximately half its diameter every minute) and this can cause blurring when using exposures of several seconds or more (and the longer the lens, the more acute the problem). To avoid this I pushed the film by one stop (exposing and having my ISO 100 film developed as if it were ISO 200) and used a shutter speed of six seconds. When using a standard lens this is the longest exposure I would recommend you use to photograph the moon.

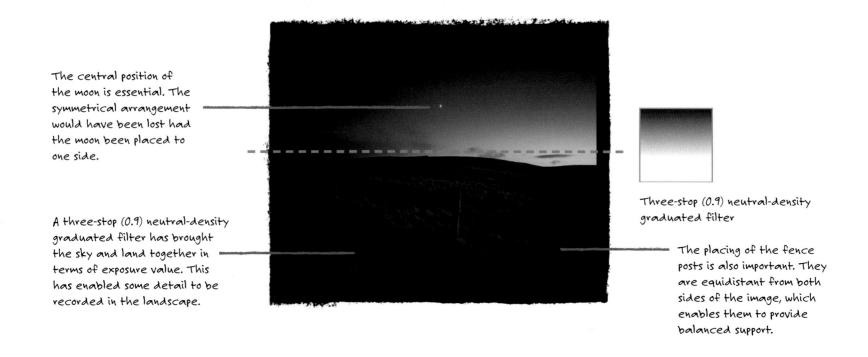

The central position of the moon is essential. The symmetrical arrangement would have been lost had the moon been placed to one side.

A three-stop (0.9) neutral-density graduated filter has brought the sky and land together in terms of exposure value. This has enabled some detail to be recorded in the landscape.

Three-stop (0.9) neutral-density graduated filter

The placing of the fence posts is also important. They are equidistant from both sides of the image, which enables them to provide balanced support.

North of Glenluce, Dumfries & Galloway, Scotland

CAMERA: Tachihara 5x4in (12x6cm format back)
LENS: Rodenstock 120mm (Semi Wideangle)
FILM: Fuji Provia 100
EXPOSURE: 1/2sec at f/27 (sometimes shown as f/22½)
WAITING FOR THE LIGHT: 50 minutes

A Contemporary Approach

It wasn't the weather for photography. Even close-up subjects were ruled out by a steady drizzle and I had contemplated giving up for the day. There were, however, a couple of hours of daylight left, so I made the short journey to Porlock Bay, where I waited in the hope that conditions would improve. The rain did eventually stop, but my attempts to find a picture along the rocky coastline were thwarted by the incoming tide. However, all was not lost.

The normally windswept coast was, for once, still and calm. Sky and ocean shared the same texture and the same soft, luminous glow. I was drawn towards the perimeter of the bay where it swept into the ocean, its solid form in stark contrast to the ethereal elements surrounding it. This was an image of the most minimal content. It was very appealing but then I am, by nature, a minimalist. I find the landscape in its most elemental form to be compelling and the perfect subject for the camera.

In my humble (and possibly biased) opinion I believe that photography stands alone as the art form perfectly equipped to depict these distillations of landscape. Bordering on the abstract, contemporary minimalism is not, however, an approach that can be universally applied to every situation. The style needs to be used judiciously because it can so easily end in failure and disappointment (I speak from experience when I say this!). However, used creatively, it can often produce distinctive, eye-catching images.

As always, observation is a key factor in the creation of this type of picture. As I stood looking at the view over the bay I knew that in order for it to succeed I would need to further soften the sky and water. This required a shutter speed of four seconds. A shorter exposure would have given a crisper definition to the elements; the contrast with the water and the tree branches (which are an essential detail) would have then been lost, as indeed would the photograph.

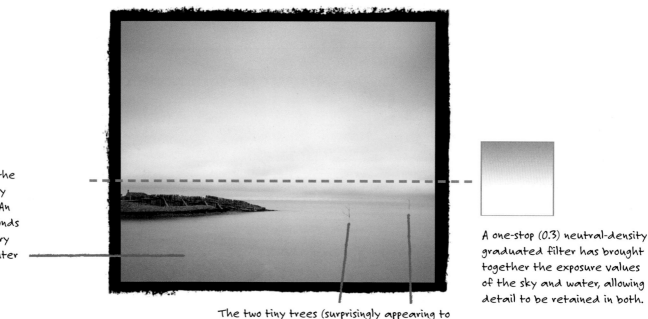

The fluid definition of the sky and ocean is the key element in this picture. An exposure of several seconds will normally be necessary to soften clouds and water in this way.

The two tiny trees (surprisingly appearing to survive in the salt water) bring a balance to the arrangement and prevent the image from being one-sided.

A one-stop (0.3) neutral-density graduated filter has brought together the exposure values of the sky and water, allowing detail to be retained in both.

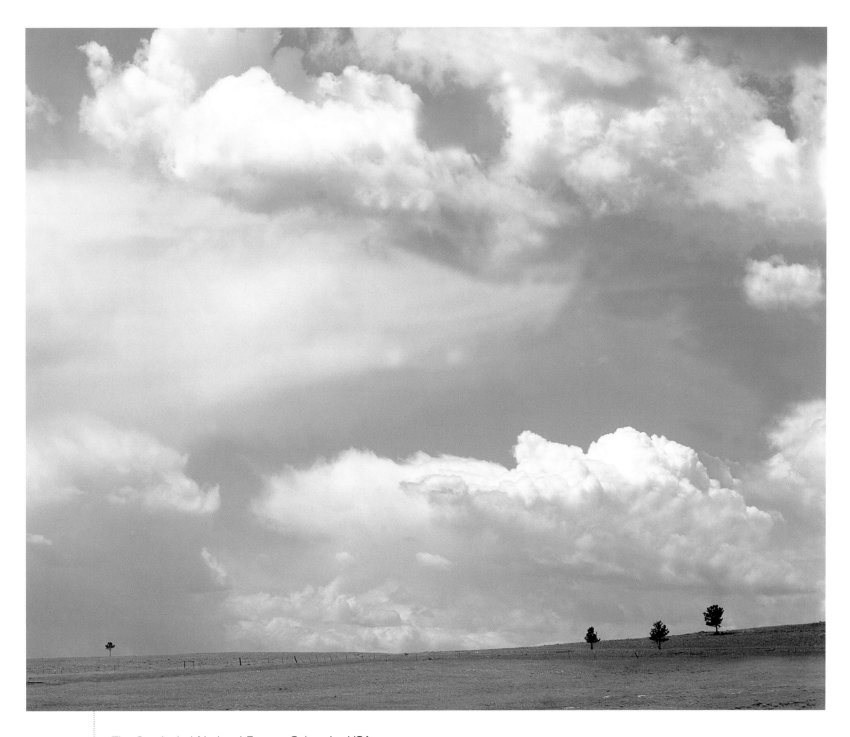

The San Isabel National Forest, Colorado, USA

CAMERA: Mamiya RB67
LENS: Mamiya 300mm (Telephoto)
FILM: Fuji Provia 100
EXPOSURE: 1/15sec at f/27 (sometimes shown as f/22½)
WAITING FOR THE LIGHT: 4 days

A Precise Arrangement

This in many ways is the equal and opposite to the photograph on the previous page. Unlike the earlier picture, the two elements that form this photograph were not a ready-made pair. Their positioning and relationship are, however, the key to the picture, but when I first saw them they were not in any way connected. The row of trees was directly in front of me and in fairly close proximity, while the forest-clad sloping hillside was way off in the distance and situated to the right.

I could see that the two were potentially compatible, and contemplated that, if correctly positioned, the arrowhead shape of the hillside could lead the eye perfectly to the group of trees. But the arrangement had to be precise. By walking to the left and approaching the trees from a different direction, I was able to bring the sloping hill into the picture. It was then a matter of walking backwards and forwards and to the left and right until I was happy with the composition. There was no margin for error and it took thirty minutes of experimenting before I was satisfied with the result.

Again I used a long telephoto lens, which had the effect of bringing the hillside within 'touching distance' of the trees. This flattening of perspective caused by using a telephoto lens at a distance also strengthens the picture. This is because the photograph doesn't require depth; it is an image that consists only of simple shapes. Its minimal content is its strength, which is why, in contrast with the previous picture, a clear sky is the perfect background. The reason for this is that the subject here has a stronger presence than those tiny trees. This time they can stand on their own without the need for any support. The presence of clouds is therefore unnecessary and would have been a distraction; they would have merely competed with the main subject and would have made no positive contribution.

The success of this image rests on the spatial relationship between the two elements. It was therefore important that they were placed in close proximity but were not allowed to merge or even touch.

The polarizer (half polarized) has darkened the sky slightly. A fully polarized effect would have looked too severe and would have detracted from the simplicity and theme of the image.

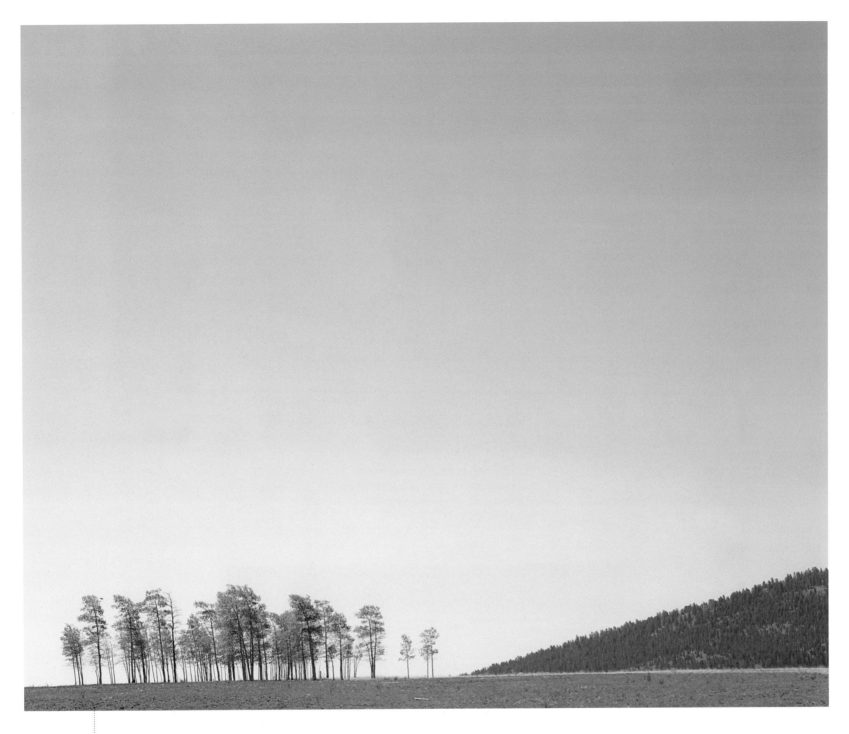

The San Isabel National Forest, Colorado, USA

CAMERA: Mamiya RB67
LENS: Mamiya 300mm (Telephoto)
FILM: Fuji Provia 100
EXPOSURE: 1/30sec at f/27 (sometimes shown as f/22½)
WAITING FOR THE LIGHT: 30 minutes

Across the Threshold

As I set foot into this forest, my reaction was one of elated anticipation. I felt I had suddenly entered a world of opportunity. The colours and the graphic lines and shapes were quite enchanting and were crying out to be photographed. The path that leads into the forest is adjacent to the roadside and the first thing I saw was the picture that you see here. All I had to do was step out of the car and walk straight into this wonderland.

The golden rule, however, is that you should never snatch at a photograph, because your first view might not be the best. So, applying this rule, I made a careful exploration of the entire area. It wasn't huge and after two hours of foraging I was happy I had seen everything. I was expecting to find hidden treasures buried in the heart of the forest but it wasn't to be. I was surprised but not disappointed. I returned and took the photograph I had initially seen and I am very satisfied with the resulting image. I think it is a most entrancing picture. It has a repetitive, but relaxed, symmetry and a lovely combination of rich, textured colour.

But there is, I believe, another dimension to the image. I think this photograph also works on a subliminal level. The vanishing footpath takes the viewer on a journey into the unknown. It crosses the threshold into a mysterious, hidden world. Where does the path lead? What lies beyond the wall of trees? What secrets does the forest hold? The answers lie, of course, in the viewer's imagination.

My contribution to the creation of this picture was negligible. I did little more than place my camera on its tripod, take a meter reading and release the shutter. It was hardly ground-breaking, creative photography, but sometimes nature hands you something that can't be improved. The role of the photographer is then merely to record what is there.

The panoramic format emphasizes the expanse of the forest and helps to create an 'all-embracing' three-dimensional quality.

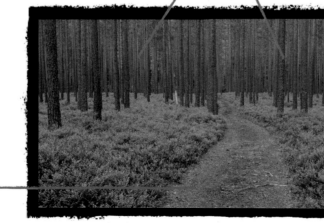

Highlights or areas of sky should always be excluded. The objective is to create a landscape that consists entirely of forest and no other elements.

The central position of the footpath enhances its presence. It also strengthens the symmetry of the picture by dividing the foreground into equal thirds.

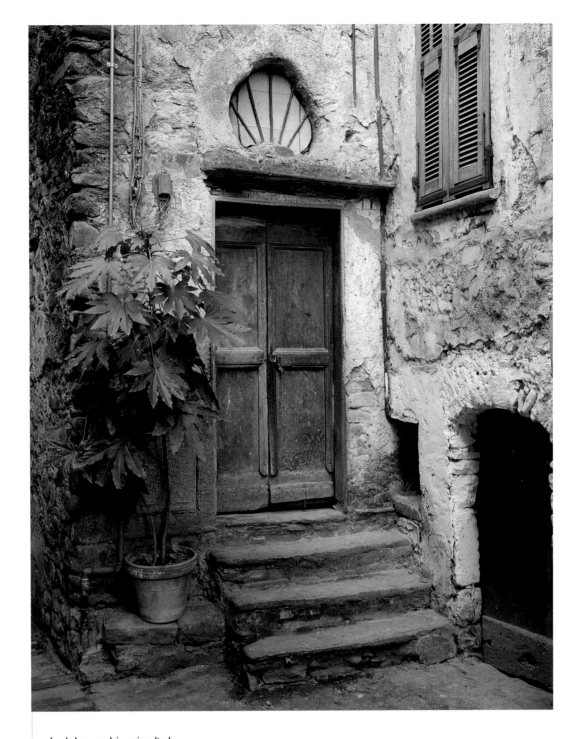

Isolabana, Liguria, Italy

CAMERA: Tachihara 5x4in
LENS: Super Angulon 150mm (Standard)
FILM: Fuji Provia 100
EXPOSURE: 1 second at f/38 (sometimes shown as f/32½)
WAITING FOR THE LIGHT: Immediate

A Slice of Landscape

The sky looked promising as I set off towards the New Brighton coastal area. Optimistically, I was hoping that the day would end with a glorious mackerel sunset. Unfortunately, the finely structured cloud gradually decreased and the sky eventually became completely clear. All was not lost, however, because a warm glow developed as the sun sank below the horizon. I realized that another picture was beginning to emerge, quite different from the one I had in mind originally.

As I watched the colour of the sky intensify I was attracted by the simple, but very effective, arrangement of the silhouetted promenade railings and lights. There was a strong aesthetic quality to the lines and curves and the twilight sky was the perfect backdrop for the almost abstract arrangement.

Technically, it was a simple photograph to take. I took meter readings of the brightest and dimmest areas of the sky and then based exposure on the average reading. Exposing for the sky created a silhouette effect, which works well for this subject because there is no detail as such to be recorded. This is an image of stark simplicity and this quality is strengthened by allowing the subject to fall into silhouette.

A slice of landscape can often depict the character of a place far more effectively than a bigger view. Here, this utterly simple two-dimensional image encapsulates, to my mind, the spirit and tradition of the British coastal resort.

No filters were necessary here. I based exposure on the sky and allowed the railings and lights to be recorded as a silhouette.

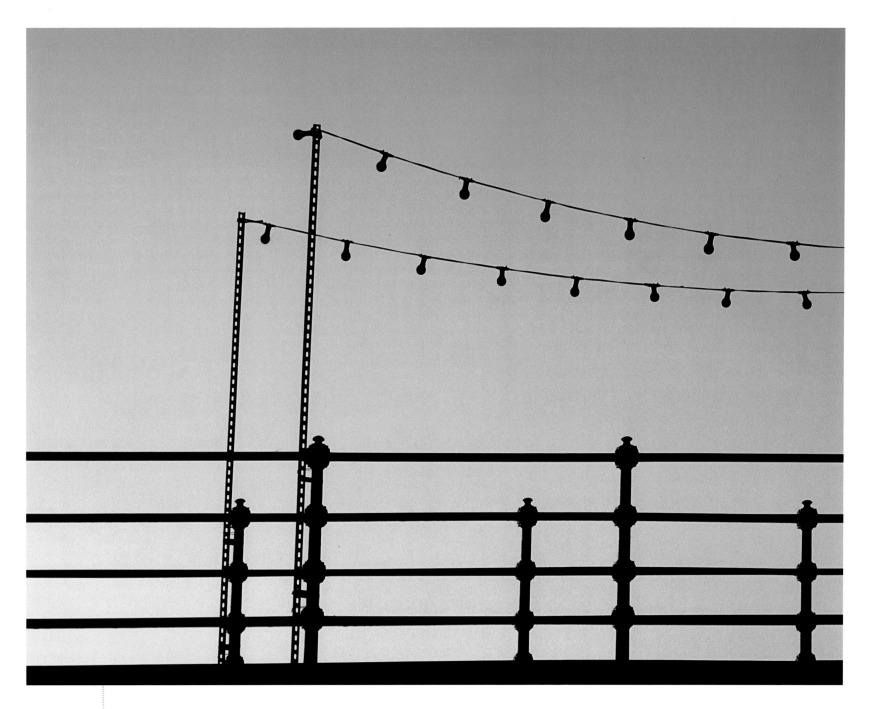

New Brighton, the Wirral Peninsula, Merseyside, England

CAMERA: Tachihara 5x4in
LENS: Fujinon 300mm (Short telephoto)
FILM: Fuji Provia 100
EXPOSURE: 1/2sec at f/22
WAITING FOR THE LIGHT: 20 minutes

Searching for those Precious Elements

Where do I start, you may be wondering. It's not quite as bad as looking for a needle in a haystack but the search for eye-catching elements can certainly seem like a daunting task. To point you in the right direction, I list those places which, from my experience, are the most likely to prove fertile hunting ground.

The coast
There is nowhere better. It is alive with opportunity. Look for patterns as waves break on the shoreline. The shape and texture of surf on the beach, the pattern and texture of wet sand, the arrangement and colour of sea shells – it's all there awaiting discovery. Look also at rock formations. Find the right location and you can enter a microcosm that is a haven of opportunity to the photographer.

The countryside
Drystone walls are rich in colour and texture, while old fences and gateposts provide scope for creative close-up photography. Arable farmland produces ever-changing images of graphic patterns as crops are grown and harvested. Then there are hay meadows and pasture land. They are a sight to behold and a joy to photograph.

Near Penzance, Cornwall, England
Rocky coves and inlets are a potential goldmine. Large-scale maps are a useful aid to pinpointing areas of interest. Tide timetables are also helpful. Visiting a beach as the tide recedes will give you sparkling, pristine sand to photograph.

Near Capel Curig, Snowdonia, Wales
Many years of exposure to the elements can produce strong visual images from fairly mundane objects. Here the growth of moss and lichen brings a rich colour and texture to a traditional stone wall.

Woodland and forest

Within these wonderlands there are pictures galore for the keen-eyed photographer. Look for wild flowers, colourful autumn leaves, tree bark and roots, fungi, trickling streams – there is always something of interest hidden away. Consider, too, the effects of seasonal changes. Photographs can emerge – sometimes quite fleetingly – at any time, from the depths of winter to the height of summer.

Towns and villages

The urban landscape should not be ignored because it can be a source of many striking images. Seek out the oldest parts of a town (usually its centre) and look closely at the detail of the buildings. Be aware that a close inspection is often necessary to spot the gems that can remain hidden beneath the surface. Traditional fishing ports and harbours are also always worth a visit. Out of season, popular resorts often shed their cloak of commercialism, enabling you to photograph the streets and alleyways without passers-by inadvertently walking into your shot.

Monti di Villa, Tuscany, Italy
Wood doesn't have to be growing for it to make an interesting photographic subject. Here the variety and combination of shape, colour and texture has produced an engaging and aesthetically attractive image.

Soldano, Imperia, Italy
Often it is the unlikeliest buildings that make the strongest subjects. This photograph of an old workshop is structured around those glorious blocks of colour and the perfectly positioned bicycle (which is exactly where I found it!).

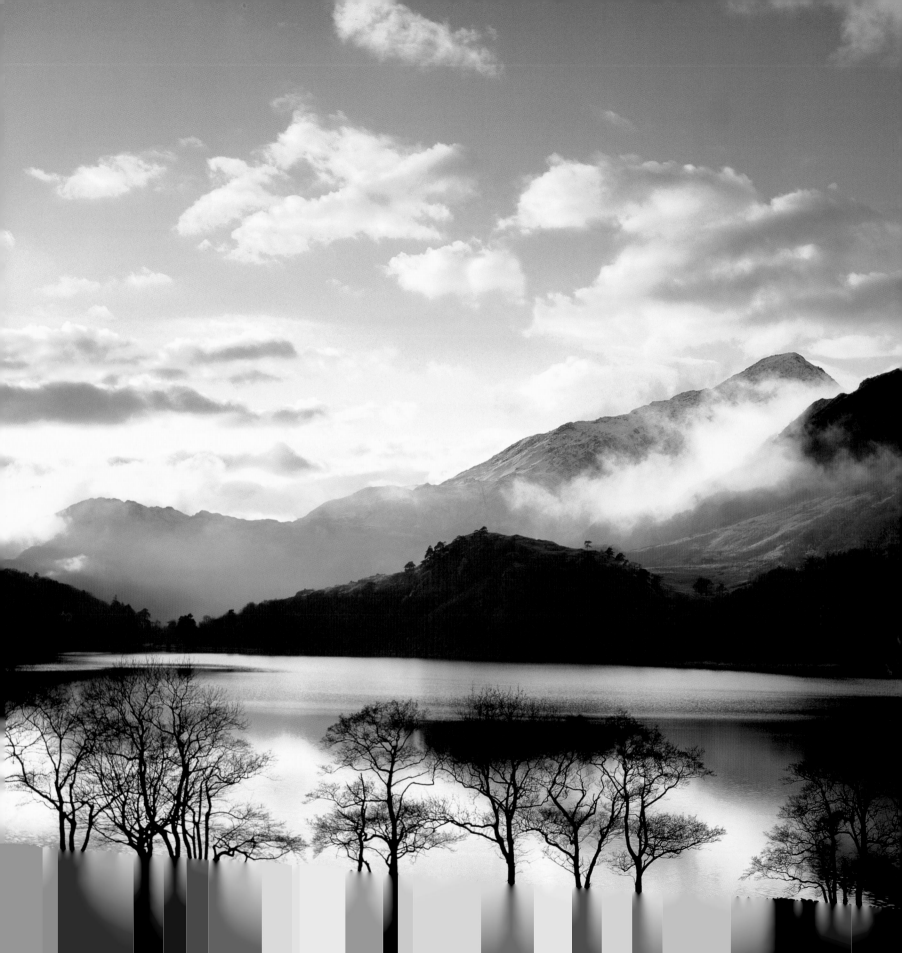

CHAPTER THREE

The Creative Use of Filters

Llyn Gwynant, Snowdonia, Wales

The short mid-winter day ended on a glorious note, but to capture the magnificence it was necessary for me to use a one-and-a-half stop neutral-density graduated filter to reduce the brightness of the sky to that of the water; this enabled both the sky and lake to be correctly exposed. I then emphasized the warm glow of the back-lit clouds by adding an 81C warm-up filter.

CAMERA: Tachihara 5x4in
LENS: Super Angulon 90mm (Wideangle)
FILTER: 81C warm-up filter
FILM: Fuji Provia 100
EXPOSURE: 1 second at f/27 (sometimes shown as f/22½)
WAITING FOR THE LIGHT: 45 minutes

When I photograph the landscape my objective is always the same. I attempt to reproduce the scene faithfully, exactly as I see it. This is easier said than done, though, because the human eye and film or digital chip see things quite differently. The combination of eye and brain is remarkably adept at adjusting the image that we register as seeing, and is way ahead of even the latest technology in this respect. A helping hand is therefore often necessary to compensate for the limitations of the photographic materials at our disposal.

However, I am not a believer in gimmicks or gadgets, or in fact anything that compromises the integrity of a photograph and I therefore avoid manipulated images. That said, there is a fine line between manipulation and compensation and it is easy, in the heady pursuit of the perfect image, to cross that line unwittingly. At best, any subtle qualities in the photograph will at that point be lost, and at worst the picture will degenerate into a jarring portrayal of nature at its most unnatural.

To avoid such pitfalls I use only a small number of filters, whose functions are to (a) compensate for variations in the colour of daylight and (b) reduce the intensity and contrast of light. There are three groups of filter that perform these tasks, namely:

neutral-density (ND) graduated filters,
the 81 series of warm-up filters,
the polarizing filter.

If used thoughtfully, these filters can bring considerable improvement to many photographs. They are an essential tool and should, I suggest, be carried by every landscape photographer. The benefits they can bring will quickly become apparent!

Darkening the Sky

A question I am asked more frequently than any other concerns the use of the neutral-density (ND) filter. The subject invariably arises during my talks and presentations and regularly appears in my correspondence. Specifically, the question concerns the measuring of the exposure values of the sky and land and the effect of using the filter. I would like to explain the method I employ.

Firstly, I always use a spot meter. They are not absolutely essential but are very, very useful. I take a number of spot readings (typically three or four) from different parts of the landscape and arrive at an average exposure. For illustration purposes, let's say it is one second at f/32. I then take another three or four spot readings of the sky. I generally avoid any extreme areas of light or dark (e.g. close to the sun or a black thunder cloud). This time we'll say the average reading is 1/4sec at f/32, which is, of course, two stops brighter than the landscape. My aim is to bring the relative values of both sky and land together and to achieve this I would use a two-stop neutral-

density graduated filter. Note that some manufacturers denote filter strengths as follows: 0.3 = 1 stop, 0.45 = 1½ stops, 0.6 = two stops, and so on.

I carefully position the filter to ensure the dark portion covers the sky only. I then use the exposure reading based on the landscape, i.e. one second at f/32. There is no need to adjust exposure to compensate for the filter because it has no effect on the landscape; its sole function is to darken the sky, and for exposure purposes it should be ignored.

In this picture of Loch Na Moracha my spot meter readings indicated an exposure of 1/2sec at f/32 for the sky and 1/2sec at f/19 for the landscape, i.e. a difference of one-and-a-half stops. I therefore used a 0.45 neutral-density graduated filter, which absorbed one-and-a-half stops of light from the sky, and photographed the image using an exposure of 1/2sec at f/19. As a result of using the filter, the photograph has been correctly exposed for both sky and land.

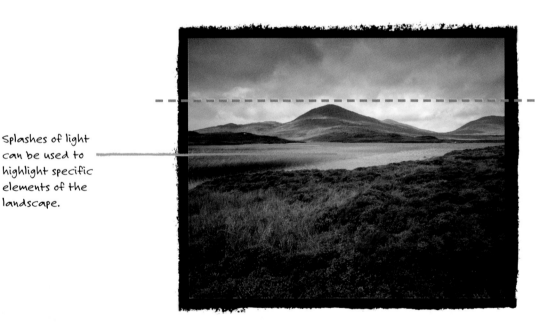

Splashes of light can be used to highlight specific elements of the landscape.

A one-and-a-half stop (0.45) neutral-density graduated filter has been used. The dark portion of the filter darkens only the sky. The positioning of the filter ensures that the rest of the image is not affected by its presence.

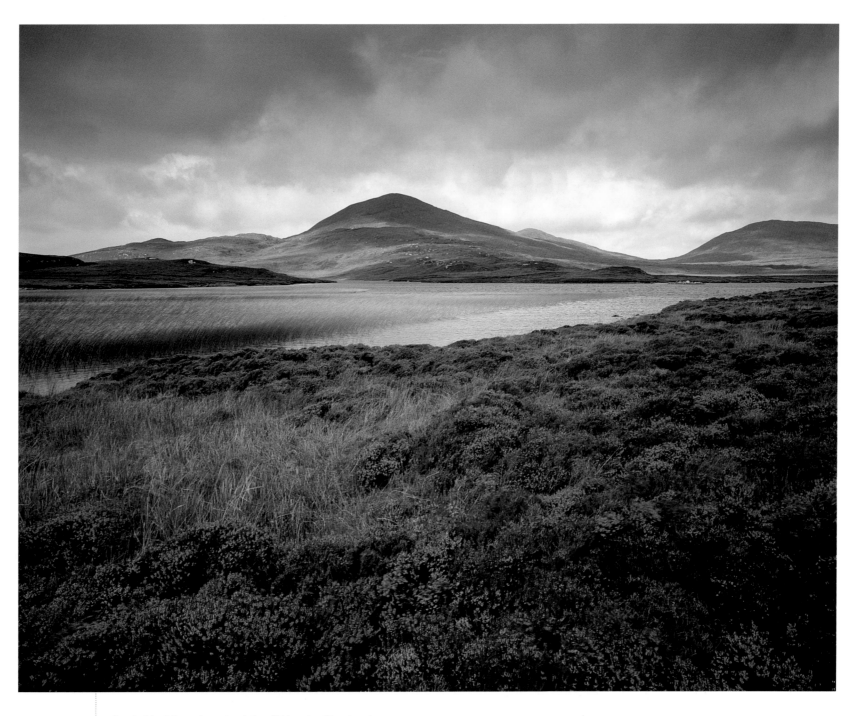

Loch Na Moracha, the Isle of Harris, Scotland

CAMERA: Tachihara 5x4in
LENS: Super-Angulon 90mm (Wideangle)
FILM: Fuji Provia 100
EXPOSURE: 1/2sec at f/19 (sometimes shown as f/16½)
WAITING FOR THE LIGHT: 2½ hours

A Minor Miracle

A rainbow – at last! I say this because in my many years of photographing the landscape I had, until this point, never managed to capture one of these fleeting moments in all their glory. This is one of the drawbacks of using the somewhat cumbersome large-format (5x4in) view camera. However, after years of near misses, the unexpected happened. As I strolled around the lake, out of the blue (or I should say grey) this marvellous vision began to develop. The problem was that my equipment was locked in my car quite a distance away. You can imagine my horror. I was looking at the most perfect photograph but had virtually no prospect of capturing it.

I walked back to the car. I decided that there was no point in running. If it was meant to be, it would be; fate would determine the outcome. I collected my camera case, film, tripod and umbrella. It wasn't raining at that moment but where there's a rainbow there's certain to be rain not that far away and I didn't want to get caught out. As I returned to my chosen spot, the rainbow began to fade but I continued because in the right conditions rainbows can often reappear, and my instincts were telling me that I just might be in luck. As I positioned my tripod a steady drizzle began to fall. Setting up a large-format camera is, at the best of times, a slow, elaborate process. Setting it up in the rain, one handed, while holding an umbrella, racing against time as your subject plays hide and seek is altogether a different matter. I will merely say that it is not an experience I ever wish to repeat.

To my relief, and indeed amazement, the rainbow reappeared for 30 seconds or so just as I was focusing the camera lens. Everything was perfect. The rain had abated and the slight breeze had dropped, which helped to create that glorious reflection on the lake's surface. There was just time to fit a neutral-density graduated filter, insert the film back and take an exposure reading. I managed to take just two pictures before the rainbow vanished. As a precaution I then took a third shot, which I would later use as a test exposure when having the film processed.

Looking back I realize how incredibly fortunate I was. The timing of events was a minor miracle and this picture serves as a reminder to me that any disappointments and bad luck should not be dwelt upon. Good fortune has a habit of presenting itself at the unlikeliest moments and the balance will then be redressed.

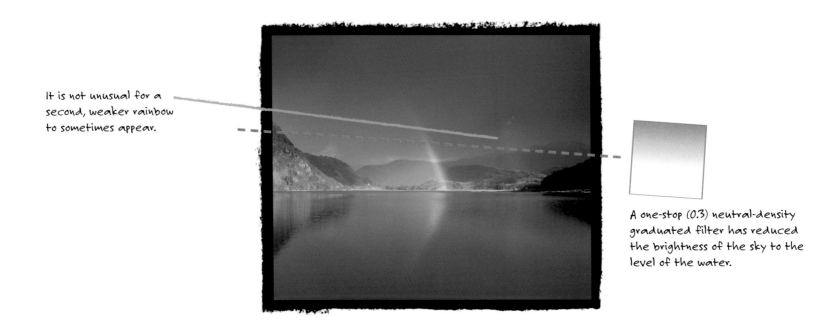

It is not unusual for a second, weaker rainbow to sometimes appear.

A one-stop (0.3) neutral-density graduated filter has reduced the brightness of the sky to the level of the water.

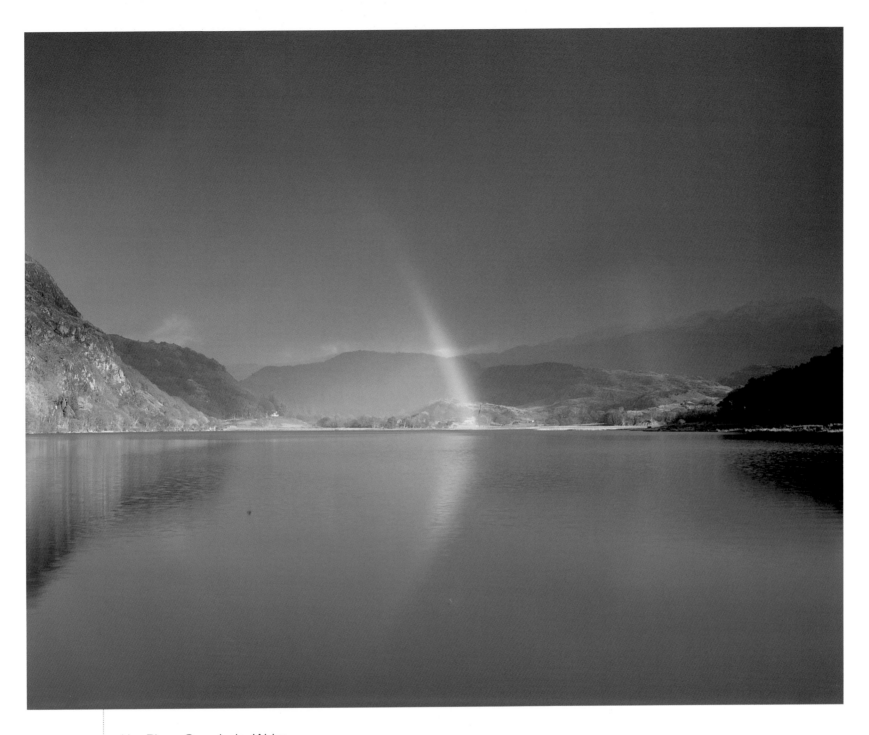

Llyn Dinas, Snowdonia, Wales

CAMERA: Tachihara 5x4in
LENS: Super-Angulon 150mm (Standard)
FILM: Fuji Provia 100
EXPOSURE: 1 second at f/32
WAITING FOR THE LIGHT: Immediate

Capturing the Sky

I think the term 'landscape photographer' is perhaps a little misleading. I say this because, in practice, we devote most of our attention to what is happening some way above the ground. It is, of course, the sky – that fickle, transient, unpredictable, and at times infuriating, mass of atmospheric water and gases – that governs our thoughts and rules our lives. Its domination is absolute; every image we create is affected by its mood and whims because, invariably, it is the sky, and the light emanating from it, that determines the success or failure of the pictures we capture. We are, in reality, sky photographers.

In this picture of Norfolk farmland there is no doubt where the main attraction lies. Remove the sky from the photograph and you're left with an attractive, but hardly spectacular, farmhouse surrounded by an unexceptional field of crops. The power of the sky is manifest and has transformed the image. It has been elevated by the presence of the heavy, threatening clouds which dominate the land below, bringing a sense of isolation and vulnerability to the tiny farm.

Accurate exposure is of critical importance if the mood and structure of a strong sky is to be effectively captured. Here I have used two separate one-stop (0.3) neutral-density graduated filters. I positioned one slightly above the other and allowed them to overlap in the top third of the picture. This has added weight to the upper half of the sky, which reinforces its presence. Using two filters in this manner also softens the graduation and produces a seamless and completely natural transition from dark to light.

The combination of two overlapping one-stop (0.3) neutral-density graduated filters enhances the cloud structure and gives the sky weight but retains the natural appearance.

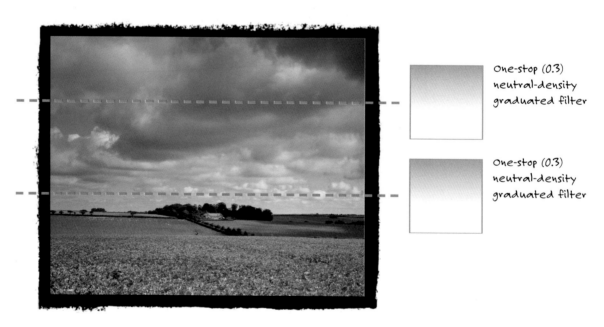

One-stop (0.3) neutral-density graduated filter

One-stop (0.3) neutral-density graduated filter

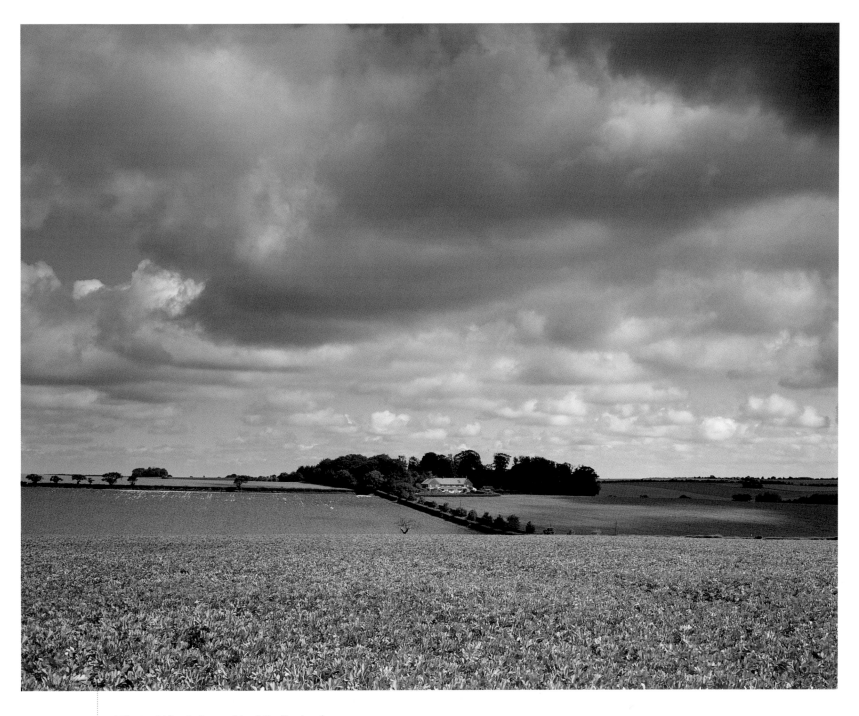

West of King's Lynn, Norfolk, England

CAMERA: Tachihara 5x4in
LENS: Super-Angulon 150mm (Standard)
FILM: Fuji Provia 100
EXPOSURE: 1/4sec at f/32
WAITING FOR THE LIGHT: 45 minutes

The Polarizing Filter

The polarizer is a very effective filter and, if used with care, can bring a noticeable improvement to many landscape photographs. It works by absorbing polarized light and has two functions.

First and foremost the filter has the marvellous ability to darken a blue sky without affecting the brilliance of the clouds; this will give the sky a dynamic appearance and will enhance the presence of cloud. This can be beneficial but the filter should at all times be used with caution. This is because the effect can look exaggerated, particularly with a wideangle lens, as uneven darkening in one corner can occur. Broken cloud is helpful in this respect because it can be used to cover the area (that is, the corner furthest from the sun).

The filter's ability to absorb polarized light also enables it to suppress surface reflections. This will remove unwanted highlights and, as a result, it will strengthen and saturate colour. This can be particularly useful in damp weather when moisture droplets are present. The filter absorbs light from every type of surface (including water) with the exception of metal.

The polarizing effect is controlled by rotating the filter. It is therefore possible – and sometimes desirable – to fine-tune the effect, perhaps half-polarizing the sky by turning the filter half a revolution. This will normally improve the sky's colour but will retain a natural appearance.

The two photographs on these pages graphically show the effect of using this filter. The main picture has, quite obviously, been polarized. When compared with the smaller, non-polarized photograph you can see that the grass has a much richer colour and texture. The sky, too, shows the unmistakable sign of being polarized. I overdid it, in fact, and the sky has suffered as a result. I should have exercised restraint and only half-polarized the light. We do, indeed, continually learn by our mistakes.

It should be remembered that a filter's presence should never be apparent; under-use is therefore always preferable to over-use.

The 81B warm-up filter has strengthened the colour of the moorland grass and has compensated for a bluish cast.

81B warm-up filter

Polarizer (fully polarized) (Main picture)

This is the non-polarized photograph and the difference is quite noticeable. The colours are much weaker and they lack impact. The sky, however, does not suffer from uneven darkening, as is the case in the main, polarized picture.

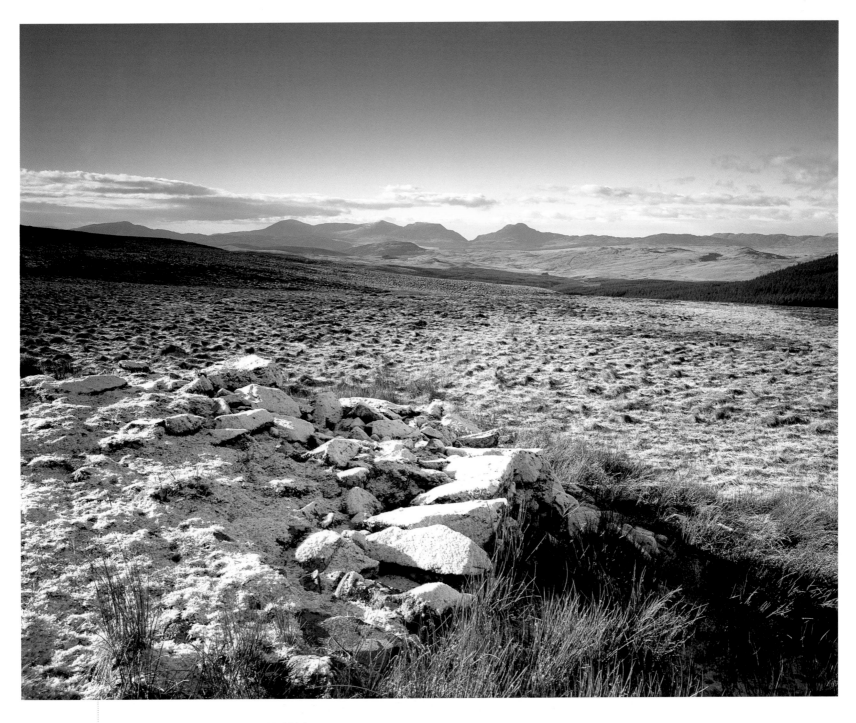

South-west of Bala, Gwynedd, Wales

CAMERA: Tachihara 5x4in
LENS: Super Angulon 90mm (Wideangle)
FILM: Fuji Provia 100
EXPOSURE: 1/2sec at f/32
WAITING FOR THE LIGHT: 1 hour

A Glimpse of Wild Nature

Jackman Station was built in the pioneering years of rail transport. Dating back to 1886, it is now quite evidently no longer in use, which makes it, of course, an interesting subject for the photographer. These dilapidated buildings are some way from the station and it was a chance encounter that led to their discovery. On their own they are not spectacular, but grouped with the surrounding trees and overgrown grasses they make a fine study of a landscape which, perhaps unintentionally, is being allowed to regain part of its lost ground.

There are some imperfections in this picture, not least of which is the light; it is too harsh and this is a consequence of my photographing in the middle of the day under a cloudless sky. I had ruled out early morning and late afternoon because the sun, although weaker at those times, was then in an unfavourable position. I should, however, mention that the resulting high level of contrast has not been helped by my use of a polarizer. I realized the consequence of using the filter but felt it was an acceptable price to pay. The polarizer has brought a discernible improvement to both the sky and the colour of the surrounding foliage. The strength of this image lies, to a degree, in the bold colours and the contrast between the trees and sky, which are a perfect foil for each other.

Another shortcoming of this image is the gravelled area in the bottom left corner. It had to be included because it would have necessitated framing the building too tightly to omit it. Ideally, the lower portion of the photograph should consist of nothing but long, overgrown grasses. This would have strengthened the 'wild nature' theme of the picture but, regrettably, there was nothing I could do to achieve this. Notwithstanding this, it remains in my view a pleasant image and one that brings back happy memories of my final few days in northern Maine.

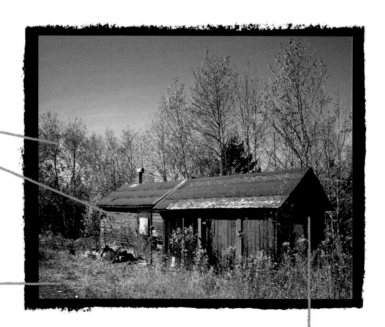

An 81B warm-up filter has enriched both the foliage and the wooden hut.

The gravelled corner is a little distracting. The picture would have been improved if the long grass had covered the entire foreground.

81B warm-up filter

Polarizer (fully polarized)

Softer light would have strengthened the colour and presence of the grasses. It would have also reduced the relatively high level of contrast, which is noticeable in the shaded areas.

Jackman Station, Jackman, Maine, USA

CAMERA: Tachihara 5x4in
LENS: Super Angulon 90mm (Wideangle)
FILM: Fuji Provia 100
EXPOSURE: 1/2sec at f/32
WAITING FOR THE LIGHT: 3½ hours

Enriching Colour

Autumn is the time of year when colour photography comes into its own. This is the season when colour becomes the subject that occupies the mind of the photographer, as other elements of the landscape are relegated to playing only a minor role. Autumn is all-embracing. Visit deciduous forests and woodlands at the right time and you will find yourself literally surrounded by photographs. It will be difficult to take a bad picture as trees burst into a kaleidoscope of colour.

The season is short-lived but can last longer than you might think because as it progresses the colourful spectacle gradually falls from branch to earth, where it then remains until the onset of winter. Observation is the key because photographs can lie hidden in the undergrowth and, although fairly ubiquitous, it requires a keen eye to spot them. However, once they are found, the making of the photograph is then a relatively simple process.

Here I used a polarizing filter to suppress reflected highlights and this has had the effect of strengthening colour. In addition, I added a mild warm-up filter. This was primarily to compensate for a cold blue cast, which can be present in diffuse light from an overcast sky, and has not had a noticeable effect on the colour balance.

There was also a degree of tidying up necessary, which included the removal of some fallen twigs and a leaf that was partly covering the fungi. Had the view of the fungi been impaired it would have been irritating to the eye when seen as a photograph. In this type of still-life arrangement everything should be clean and well ordered but without looking contrived.

Scattered grass or other forms of organic debris can look untidy when photographed. I carefully removed some unwanted twigs, taking care not to disturb the leaves or fungi.

The 81B warm-up filter has compensated for the cool daylight that often exists in densely wooded areas.

The polarizer (fully polarized) has suppressed surface reflections and has helped to saturate the autumn colour.

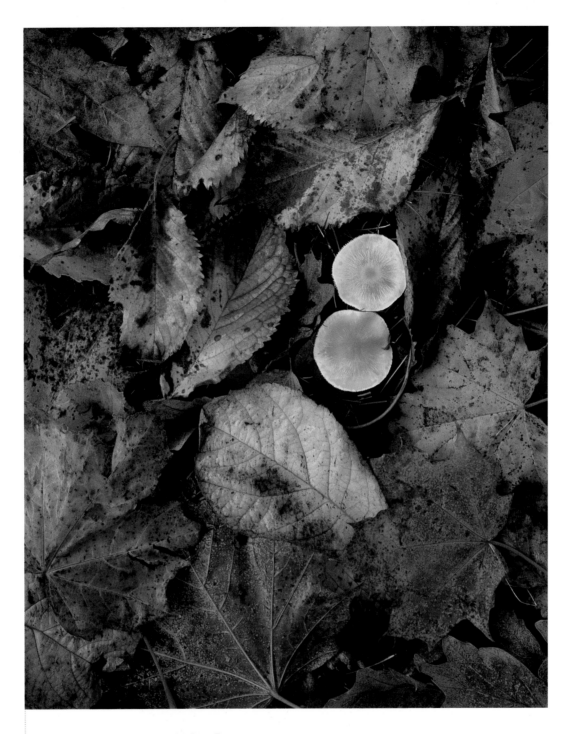

Near Saumur, the Loire Valley, France

CAMERA: Tachihara 5x4in
LENS: Super-Angulon 150mm (Standard)
FILM: Fuji Provia 100
EXPOSURE: 1 second at f/27 (sometimes shown as f/22½)
WAITING FOR THE LIGHT: 10 minutes

Blurring Water

I find flowing water compelling. I don't know what it is but there is something almost mystical about a cascading stream or river that twists and turns through the heart of a forest, bringing lifeblood to the flora and fauna. If I hear a faint trickle or splash I'm off like a shot to investigate. I'm not sure why, but I never tire of photographing them. It might be because of their uniqueness – the fact that no two are ever the same – or perhaps it is because they exist in a constant state of transition, their appearance fluctuating in accordance with the levels of rainfall.

Dull, overcast days are not, generally speaking, the days for photographing landscape. However, place a stream down the middle and you have the perfect subject for dull-weather photography. This Rocky Mountain river, although partly surrounded by trees, was also open and somewhat exposed. When I first saw it, bright sunlight was creating dappled highlights on the surface of the water. At the time it looked attractive, but as a photograph the bright spots and splashes would have been intrusive. I therefore waited (for two hours) for the sun to become obscured by cloud.

Because the stream was so open, and therefore well lit, my meter reading was indicating a relatively short exposure of 1/4sec at f/32. In order to blur the water I needed to use a shutter speed of at least one second; I therefore added a polarizing filter, which absorbed the equivalent of two stops of light. This gave an exposure of one second at f/32, which has softened and blurred the flowing stream. The polarizer has also suppressed reflections on the water's surface, which helps to accentuate the image of a fast, cascading river.

I framed the river tightly to ensure the sky was excluded. A solid border at the top of the picture helps to concentrate attention on the river below.

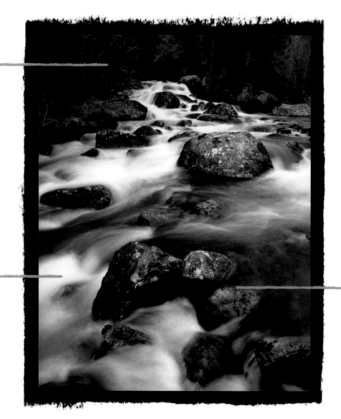

Polarizer (fully polarized)

A polarizer (fully polarized) absorbs approximately two stops of light. This can be useful when blurring water, which requires relatively long shutter speeds.

Colourful rocks are preferable to solid, black masses of stone, which can look unsightly when photographed.

CHAPTER FOUR

The Photographer's Eye

Near Kirby Stephen,
Cumbria, England

It required three visits over as many months and then finally a three-hour wait before I was able to capture this delightful arrangement. But it was worth every minute of the seemingly endless weather watching. If ever there was a piece of landscape that was created solely for the photographer, then this, in all its simplicity, is surely it. The sweeping wall and fence are so marvellously embellished by the perfectly positioned tree that together they create an appealing image whose charm transcends the humble nature of its content.

**CAMERA: Tachihara 5x4in
LENS: Super Angulon 150mm
(Standard)
FILM: Fuji Provia 100
EXPOSURE: 1/4sec at f/22
WAITING FOR THE LIGHT: 3 hours**

Give six photographers the task of photographing a specific location and you are likely to receive six different interpretations of the subject. They may be of a similar quality but in terms of composition they will be diverse. Why is this?

The creation of a photograph is a subjective act. The work of a photographer reflects his or her personality, inclinations and past successes and failures. Each individual will have a specific style because they will have developed a unique eye for the landscape. And it is this – the development of the photographer's eye – that gives images their trademark.

Pictures are everywhere but it requires keen observation to spot them. Look up and you might see shapely clouds in the sky. Do they share the same shape with any features on the landscape? Are they reflected in wet sand or in the clear water of a calm lake? Or study a field adorned with trees. Can they be arranged symmetrically? Or can they be joined by connecting lines, such as a drystone wall perhaps? You might discover an isolated farmhouse. Can the contour of the surrounding land be used to strengthen the presence of the tiny building? It is ubiquitous – but at a glance apparently incidental – features such as these that can be transformed by the photographer's perceptive eye into distinctive landscape images.

Artists can be paid no greater compliment than to have their work recognized, not from the signature in the corner of the print, but from the style of their picture. Develop your eye and your style will follow.

Poetry in Motion

I often spend hours foraging in rocky coves and beaches. There is nothing I like more than simply rummaging around and searching for the secrets that every coastline holds. It isn't just colours and patterns that attract me because, enticing as they are, there are other elements that the photographer can use. Tidal areas, for example, bring a new dimension to the coastal landscape.

It can be fascinating to watch as waves wash in to form perfectly shaped arcs around protruding rocks. The curved water has, for those few precious seconds of its existence, a beauty and purity of form that transcends the modesty of its composition. It is natural poetry in motion and an absolute joy to photograph.

I spent an afternoon in Cornwall, following the ebbing tide as it vacated St Ives Bay. It was compelling to watch, as the appearance of the beach constantly changed. I photographed water, rocks and sand in every possible combination. I also experimented with different shutter speeds, ranging from 1/30sec to four seconds.

This photograph was taken using an exposure of one second. This proved to be the most successful speed because it softened the water without weakening its definition. Longer exposures tended to produce a hazy, translucent image, while shorter exposures gave the water a harsh, jagged edge that looked unattractive.

The timing is critical, because this will also have a noticeable effect on the image produced. Both the speed and position of the wave as it breaks around the rocks has to be anticipated. It is mainly trial and error and mistimed exposures (and wet feet!) which are to be expected. This would not be my usual advice, but for this type of photograph I would suggest making a relatively large number of exposures, because you never really know what the image will look like until you see the processed film – and there are always surprises!

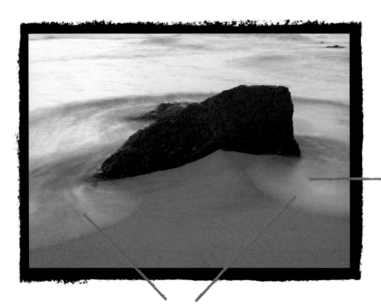

The length of exposure will have a noticeable effect on the appearance of flowing water. Here a one-second exposure has softened the waves but their shape remains intact.

Repetition of shapes and curves will heighten a picture's appeal.

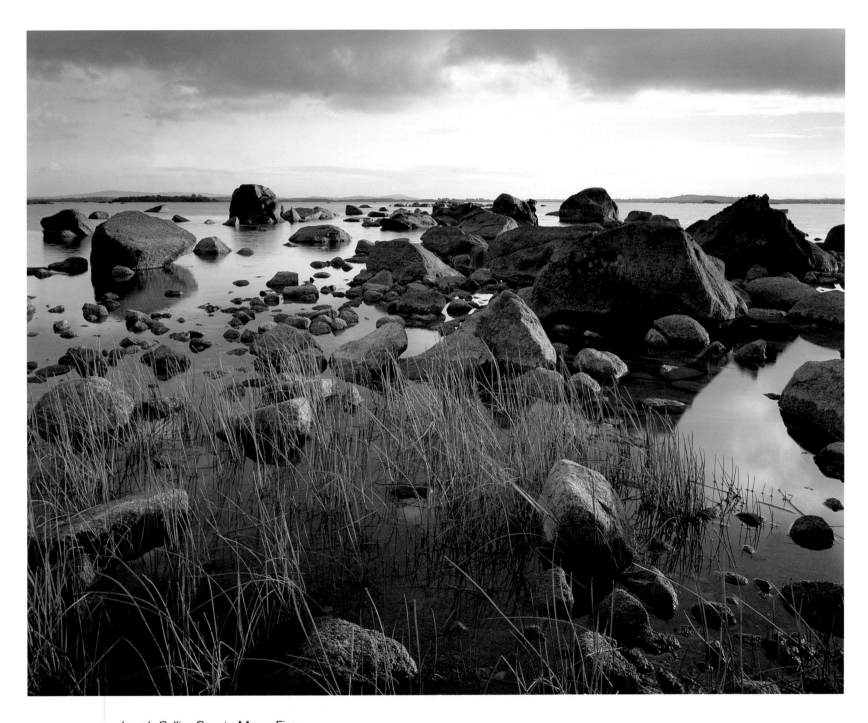

Lough Cullin, County Mayo, Eire

CAMERA: Tachihara 5x4in
LENS: Super Angulon 90mm (Wideangle)
FILM: Fuji Provia 100
EXPOSURE: 1 second at f/32
WAITING FOR THE LIGHT: Immediate

An Essence of Landscape

I was parked along a remote coastal road on the west coast of Harris. It was raining but I could see in the distance that clear weather was on the way. I had an expansive seascape in mind, which involved a strenuous descent to the water's edge, but I had no desire to get wet, so I sat in the car and waited for the weather to improve. As I gazed at the coastline I realized that much closer to hand was another picture. It was, in fact, right in front of me.

I had been so consumed with weather watching that I had missed what should have been obvious: a short distance away was a marvellous piece of rugged Hebridean terrain. Simple as it was, it perfectly captured the essence of the island. I abandoned my sea vista for the time being and made a closer examination of my new subject.

Essentially I had two options: I could either photograph it as a broad, open view and use the rocky foreground to lead towards the distance or, alternatively, I could make the weathered stones the main subject. After some deliberation I chose the latter arrangement. I was swayed by the raw drama of the landscape, which was most tangible in the foreground rocks and boulders. I wanted to emphasize them and bring them within touching distance of the viewer, so I decided to move in close and allow them to fill the lower half of the frame.

As the rain abated, broken sunlight began to play across the rocks. The angle of light was perfect but the background mountains and sky had become lost in a blanket of monotonous grey cloud. I was fortunate, however, because there was a strong sea breeze and within thirty minutes or so the sky began to open up. I was able to bide my time and pick my moment. It was, I have to say, a very satisfying experience, particularly as two hours earlier all I had seen was a distant view of the sea.

Getting the balance between foreground and background is often a subjective decision. Here I have concentrated on the boulders right in front of the camera but the distant mountains and sky still make an important contribution by depicting the rocky foreground in its wider environment.

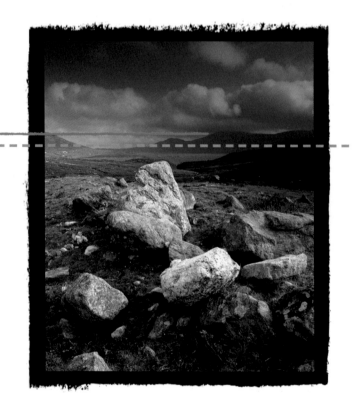

A one-stop (0.3) neutral-density graduated filter has enabled a strong sky to continue the dramatic theme set by the landscape below.

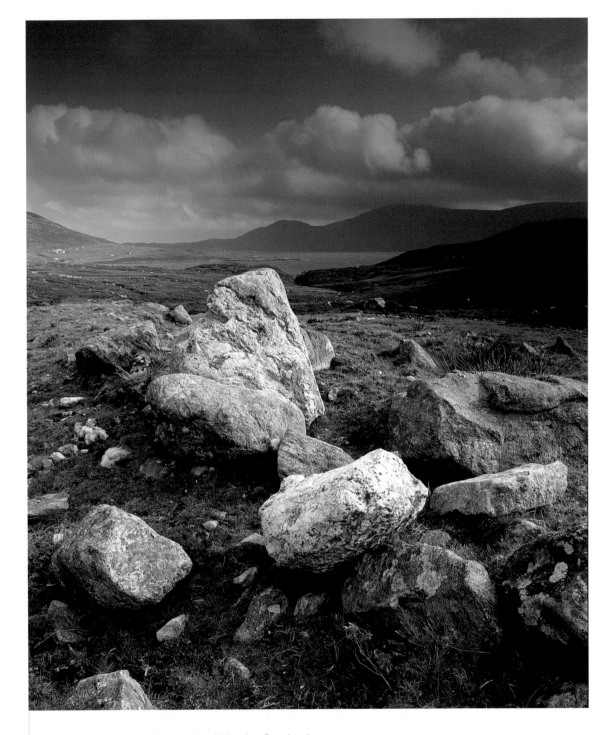

West Loch, Tarbert, the Isle of Harris, Scotland

CAMERA: Mamiya RB67
LENS: Mamiya 50mm (Wideangle)
FILM: Fuji Provia 100
EXPOSURE: 1/8sec at f/32
WAITING FOR THE LIGHT: 2 hours

A Work of Nature

The River Esk winds through the Eskdale valley in a series of twists and turns and waterfalls. I had expected that after several days of intermittent rain there would be white water crashing and tumbling through the rocks, but surprisingly this wasn't the case. The river was tranquil and I was, initially, a little disappointed. It was, however, a good day for close-up photography and there was an abundance of autumn colour, so I began to search for hidden wonders.

The Eskdale fells are truly delightful and it is a pleasure simply to stroll along the banks of the river as it meanders through forest and woodland. But beware: I have learned from experience that on such occasions it is important to remain objective. The atmosphere can engender an unworldly, hypnotic charm that can dull the senses. Don't drop your guard. The whisper of trickling water and the scent of the earth won't transfer to your film. You have to create an image that will stand up on its own without the need for background accompaniments.

I was therefore cautious as I contemplated this view along the river. To give the picture impact I wanted to fill the frame from top to bottom with colour and detail. The floating leaves and variegated rocks gave me the opportunity to create a strong foreground and I was also able to adopt a (rather precarious!) position in the middle of the river that enabled me to include the bank of trees at the top of the photograph. This continued the colourful theme and has given the upper portion of the picture a necessary weight, which has prevented the image from being dominated by its foreground.

There is no flowing water in this picture but it doesn't suffer because of this. The image has a balance and harmony that I find most alluring and this, I must add, is all the work of nature; I merely photographed what was already there. Nature provides – we must seek and find.

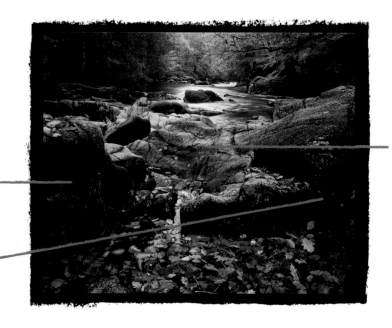

The interestingly shaped rocks are sandwiched between colourful foreground leaves and the distant river and trees. These two elements are of equal proportions, as are the rock formations on either side of the picture. This arrangement creates a balanced symmetry which is tranquil and easy on the eye and this compensates for the lack of movement in the image.

An 81B warm-up filter has compensated for the cool light of an overcast day. In addition to the trees and fallen leaves the rocks have also benefited from the presence of the filter.

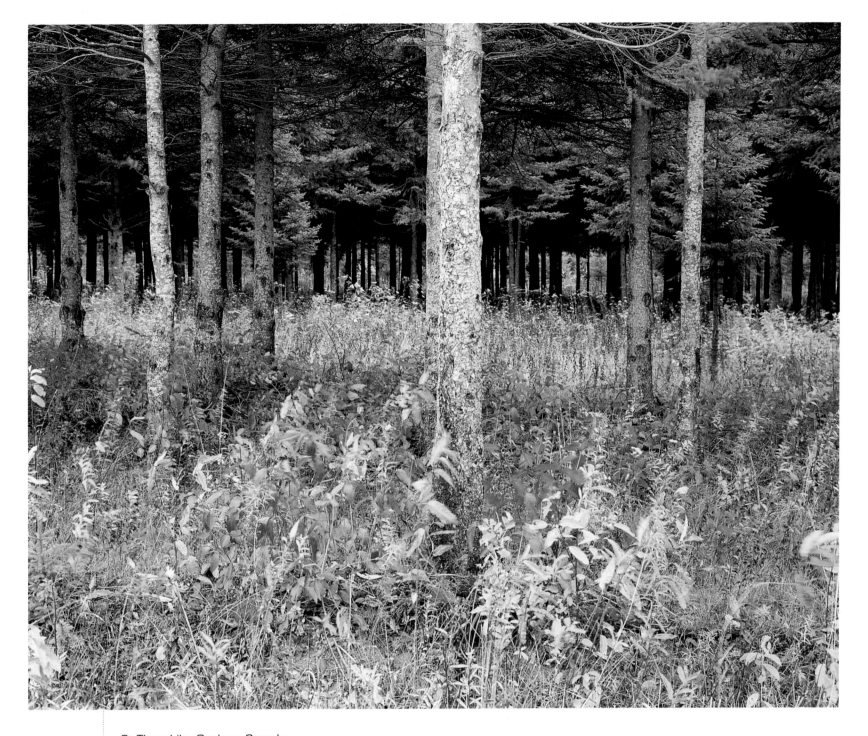

St Theophile, Quebec, Canada

CAMERA: Mamiya RB67
LENS: Mamiya 90mm (Standard)
FILM: Fuji Provia 100
EXPOSURE: 1/15sec at f/16
WAITING FOR THE LIGHT: 30 minutes

The Telephoto Lens

When I bought my medium-format camera my intention was to use it for close-up work and also as a back-up to my 5x4in camera. I bought the camera body from a friend, who also kindly offered me a 300mm telephoto lens at a very reasonable price. I thought it might be useful from time to time and gladly accepted the offer. Little did I realize that its power of magnification would prove invaluable on a surprising number of occasions, and I now never go on location without it.

The lens has a magnification that is almost double that of my longest large-format lens. This additional magnification has created opportunities that were previously unavailable to me (the equivalent large-format lens would measure in excess of 500mm, almost two feet, which is a little impractical for fieldwork!).

The photograph opposite would have eluded me had I not had the option of using a long lens. Not only was the river an impassable barrier, had I got any closer I would have lost height and the picture's composition would have been severely compromised. A lower vantage point would have necessitated the camera's angle being raised, which would have resulted in a portion of sky appearing in the picture.

This type of photograph should, generally speaking, exclude any highlight areas, as they tend to be distracting and their presence would weaken the image. A long telephoto lens is therefore ideal in this respect, because its reduced angle of view makes it possible to frame the subject tightly and exclude any unwanted surrounding elements. This is, without doubt, a very useful lens, and it is one piece of equipment that is most certainly worth its – not inconsiderable – weight in gold.

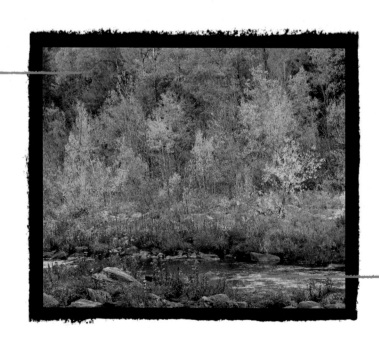

I didn't use any filters when taking this photograph. It would have been wrong to add a warm-up filter because of the background green trees. This is a picture of delicate autumnal hues and the presence of verdant greenery contributes to this theme.

The bright reflections on the surface of the river add a sparkle to the picture. A polarizing filter would have subdued them and the water would have then looked a little dull.

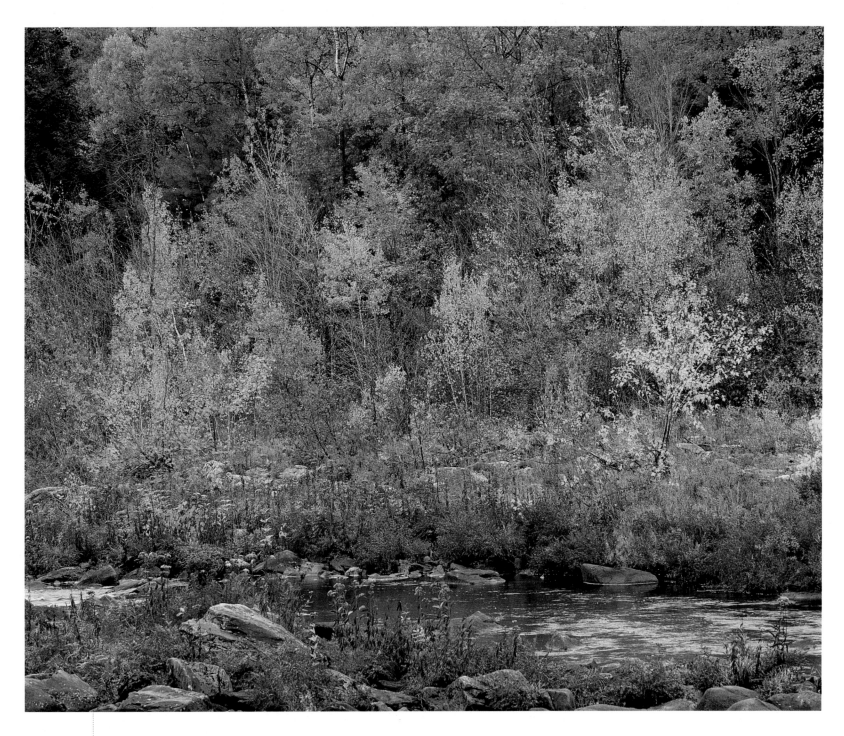

Saco River, Maine, USA

CAMERA: Mamiya RB67
LENS: Mamiya 300mm (Telephoto)
FILM: Fuji Provia 100
EXPOSURE: 1/4sec at f/22
WAITING FOR THE LIGHT: Immediate

The Effect of Focal Length

The benefit of the magnifying power of a long telephoto lens is again evident in this picture of a winding, tree-lined lane. It has enabled me to fill the frame with trees and the compressed perspective of the lens has also helped to condense and flatten the image, which strengthens its appeal. I arrived at this composition after experimenting with different focal lengths from a number of positions. There is no doubt that the ability to use a range of focal lengths is an important weapon in the armoury of the landscape photographer; however, I must sound a cautionary note...

At the time of taking a photograph you will have before you a three-dimensional view. There will be real and tangible distances between objects but, when seen as a photograph, these distances will be condensed into two linear dimensions. There remains, however, a perceived distance (and relative size) between the picture's elements. Such perceptions are determined by a combination of the camera's distance from each object and the focal length of lens used.

Lenses of different focal lengths also have different angles of view – the shorter the lens, the wider the angle. Your choice of lens will therefore greatly affect the structure of the image and this must be fully considered when the photograph is taken.

These matters should not be rushed. Zoom lenses give the photographer a choice of focal length but the camera position is of equal importance. Every permutation of position and lens focal length should be carefully assessed as part of the creative process. Your eventual choice will determine the spatial relationship of the picture's elements and will fundamentally affect the impact – and success – of your photograph. Time spent checking all the options will therefore be well rewarded.

The long lens has flattened and accentuated the curves of the lane. It also enabled me to exclude the sky and fill the frame with trees.

I waited for the sun to be obscured by a passing cloud. Strong sunlight created too much contrast, which ruined the delicate tonal range of the turning leaves.

Hilbre Island, the Wirral Peninsula, England

CAMERA: Fuji GX617
LENS: Fujinon 105mm (Standard)
FILM: Fuji Provia 100
EXPOSURE: 1 second at f/45
WAITING FOR THE LIGHT: 30 minutes

Another World, Another Time

During a recent trip to Italy I visited the Liguria and Imperia region in the north-west corner of the country. It was its convenience that attracted me, so to break up my journey I spent a few days there en route to Tuscany. I had, quite mistakenly, considered that the area's reputation as part of the Italian Riviera precluded the possibility of there being anything there that would be of particular interest to me. How wrong I was! Just a few miles from the coastal strip there exists another world and another time.

Here, high in the mountains, villages such as Perinaldo, San Biagio, Apricale and Isolabana display a medieval splendour that has to be seen to be believed. These ancient communities seem impervious to the effect of time. There are no trappings of tourism, no façade or pretension. This is the Italy of yesterday, alive and thriving today.

I was enthralled as I walked through the steep and narrow, traffic-free streets and alleyways. The colourful old buildings oozed character and they were, to say the least, numerous; I was in fact in the enviable, but perplexing, position of being spoilt for choice. I therefore decided that I would limit my photographs to a maximum of three of any one village. I have found that producing a short list in this way helps to concentrate my mind and sharpen my critical eye.

At the top of my list in San Biagio was the marvellous village piazza. Here was the Italy I had been looking for and it was a sight to savour. Nothing needed adding, moving or taking away. It was quite perfect and I had the simple, and very satisfying, task of merely photographing what was in front of me. Bellissimo!

There was a slight breeze blowing and I had to wait for the hanging clothes to become perfectly still. Any blurring would have detracted from the purity of shape and definition, which is an important feature of the image.

Confetti is a common sight in Italy's towns and villages. While I generally endeavour to tidy a subject when necessary (and this has sometimes included sweeping a street!), I rather think that in this case the sprinkling of colour adds to the authenticity of the picture.

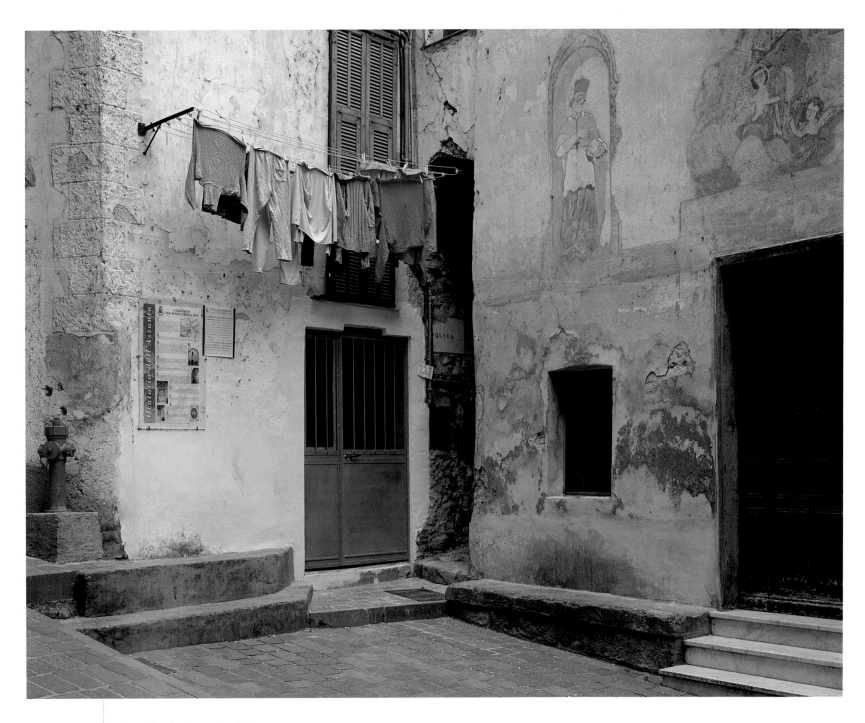

San Biagio, Imperia, Italy

CAMERA: Tachihara 5x4in
LENS: Super-Angulon 150mm (Standard)
FILM: Fuji Provia 100
EXPOSURE: 1/2sec at f/32
WAITING FOR THE LIGHT: 10 minutes

Taking a Closer Look

One of the miracles of photography is its ability to create memorable images from seemingly ordinary, everyday objects. This is where the medium of photography excels like no other art form. Look carefully and you will see that the landscape is a rich source of close-up subjects; these give the observant photographer the opportunity to produce original and engaging pictures.

This weather-beaten door is hidden away in the ancient village of Rocchetta Nervina, which is itself tucked away deep in the Ligurian mountains in northern Italy. However, images like this are by no means to be found solely in remote areas. They are surprisingly common and exist in every town, in every country, but will reveal themselves only to a discerning and observant eye.

In blissful ignorance of what I was missing I had walked past this old door a number of times in search of a wider view. It was only when I began to scrutinize the buildings that I discovered this marvellous example of luxuriant textured colour. At the time, the door was bathed in strong sunlight, and much of the tonal subtleties and tactile qualities were lost under the glare of the midday sun. What was needed was soft, shadowless light, so I returned an hour later when the building was in shade. The surface of the weathered wood now revealed its true character and, after more close scrutiny, I had no doubt that it would make an interesting and noteworthy image.

The photograph itself was simple to take. I used no filters, took meter readings from the mid-tones and made three identical exposures. For this type of picture it is invariably the seeing, not the taking, which presents the challenge.

The colourful, graphic surface needed to be photographed under flat light. Highlights and shadows would have been a distraction and the subtle tonal variations would have been lost.

When taking this type of image, you should get in close to avoid specific details becoming lost in the background.

Rocchetta Nervina, Liguria, Italy

CAMERA: Tachihara 5x4in
LENS: Super Angulon 150mm (Standard)
FILM: Fuji Provia 100
EXPOSURE: 1/4sec at f/27 (sometimes shown as f/22½)
WAITING FOR THE LIGHT: 1 hour

Using a Viewfinder

The relentless march of technology has carried photography forward in leaps and bounds in recent years. But, despite these advances, there is one critically important element that remains unchanged. In the manner of our forebears and the early pioneers of photography, we still need to see the picture. You can harness all the technology in the world but it won't take the photograph for you. Unequivocally, this aspect of image-making rests firmly on the photographer's shoulders. So, how do we develop our seeing skills?

In many ways it isn't about seeing, it's about thinking. In reality, what matters is the development of a photographer's mind as well as the photographer's eye. When photographers look at the world around them they observe shapes, colour, repetition and patterns. They are then able to translate these images into photographs. To help me do this I use a handheld Linhof viewfinder. It is designed for use with a large-format camera but it can also be used for other formats. Observing the landscape through my viewfinder enables me to isolate my subject from its surroundings and envisage the scene as a photograph. I spend the majority of my time in the field assessing the landscape in this way and would encourage you to try this method of viewing, too. Any camera zoom viewfinder will suffice for this. A handheld viewfinder is more compact and convenient, but is not essential.

Solitary Cloud
The shape and solitude of this passing cloud caught my attention as it floated by. Observing it through my viewfinder confirmed it would make a pleasing image.

Mount Wilson, NSW, Australia
My viewfinder told me that tightly cropping the trees and isolating them from the bigger view would greatly strengthen the photograph.

In order to become familiar with this approach, I would suggest that you spend time out in the landscape observing specific objects through your viewfinder. Isolate individual elements, such as trees, buildings, rock formations, flowing water, fallen leaves, or perhaps the curve of an undulating hill, or even a passing cloud – the list is endless. These are the elements which, when seen as part of a bigger picture, might not make an immediate impression but, isolate them from their surroundings and suddenly you have the making of a fine photograph.

Another benefit of using a viewfinder is its ability to help you find the best vantage point. Choosing the right camera position is of critical importance and should always be done before you set up your equipment. A viewfinder enables you to separate the seeing and the taking and this, in turn, encourages a more deliberate and considered approach.

Martindale, the Lake District, England
After considering various compositions I chose to use a short telephoto lens to concentrate on the farmhouses and trees. The longer lens has also helped to accentuate the curve of the lane. The composition and vantage point were determined by using my viewfinder before I set up my camera.

South of Tongue, Sutherland, Scotland
Big views and skies can be clinically assessed with a degree of detachment when a viewfinder is used. This will enable you to discard the photograph before, not after, you take it and will prevent subsequent disappointment – and wasted film.

CHAPTER FIVE

The Right Approach

Castle Vittorio, Liguria, Italy

I discovered this marvellous spectacle hidden away behind a dilapidated shed. It was only my curiosity which led to its discovery. When wandering through old towns and villages you literally never know what you might find around the corner. It pays to be inquisitive!

CAMERA: Tachihara 5x4in
LENS: Super Angulon 150mm (Standard)
FILM: Fuji Provia 100
EXPOSURE: 1/2sec at f/32
WAITING FOR THE LIGHT: Immediate

'How was your holiday?' I have lost count of the number of times I have been asked this question. I have also lost count of the number of times my 'holiday' has consisted of pre-dawn rises, endless travelling, searching, watching, waiting and enduring all manner of hardship and disappointments. This, I should imagine, does not match the common perception of what the life of a landscape photographer entails but it is, it should be said, a one-sided portrayal of the occupation. There are also moments of absolute, unbridled joy, moments of elation that transcend the bounds of human emotion. Often unexpected in their arrival and fleeting in their duration, such occasions feed the heart and soul of the photographer. They are the precious moments which we capture, savour and pore over.

A day on the landscape will always be unpredictable. It can be uneventful, then in the blink of an eye it can erupt in a gamut of emotional excesses. A photographer's hopes and fortunes can rise and fall with the sun. Regrettably, we exercise no control over our environment but we can learn to accept the vagaries of the pursuit philosophically. We can take comfort from our successes and build on the experience of our failures.

But is this the right approach? It would perhaps be dogmatic of me if I were to make such a claim. There is, however, no doubt in my mind that maintaining a positive attitude pays dividends. We all suffer disappointments from time to time and there is nothing to be gained from dwelling on them. There will always be a next time – and that, to me, is invariably an uplifting thought.

Establishing a Routine

You would think that photographing a big, open view in a temperate part of Australia during late summer would be a simple task. Perhaps I was being fastidious but it took me four attempts before I finally succeeded. For four consecutive days Gerry, my companion and host during my visit to Australia, and I made the 32km (20mi.) journey to the Megalong Valley. We established a routine: we would prepare a packed lunch, then my patient friend, who is not a photographer, would drive us to the valley. He would remain in the car while I would set up my equipment and embark on my ritual of watching and waiting. At various intervals throughout the day we would make short, exploratory trips into the surrounding area. If the sky showed signs of improving we would make a hasty return to my chosen spot. At the end of the day I would then drive us back to our accommodation. And so it continued...

Late in the afternoon on the fourth day I sensed that at long last conditions were becoming a little more favourable. The view was back-lit, which is potentially a very beautiful form of lighting but is also notoriously difficult to control. (High contrast, lens flare, inaccurate exposure and an unattractive sky are some of the hazards to beware of with a back-lit photograph.)

The cloud cover developed to my advantage and allowed me to use splashes of light to place a degree of emphasis on the trees in the middle distance. (This, together with the hazy blue of the mountains, helps to impart a sense of scale and distance.) The light was short-lived but I was ready and waiting. My pursuit was finally over.

So, after four days of sky watching, I had my photograph. Such a return is not, admittedly, highly productive but there has also been the (rare) occasion when a photograph has taken me just four minutes. I do not complain. Time, in any case, is an inappropriate unit by which to measure a picture. Surely a photograph should, in every sense, be timeless?

Some photographers like to reduce haze by using a UV or Skylight filter. I have never had the desire to do so because a bluish haze adds, in my view, atmosphere and depth to a photograph.

Highlight areas draw the eye and are an effective means of creating depth.

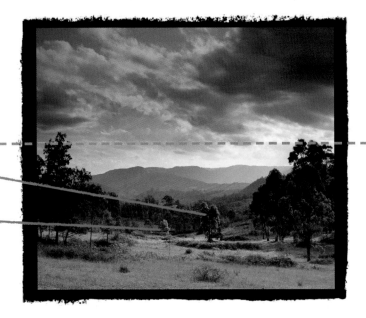

A one-stop (0.3) neutral-density graduated filter has prevented the back-lit sky from being overexposed and losing detail.

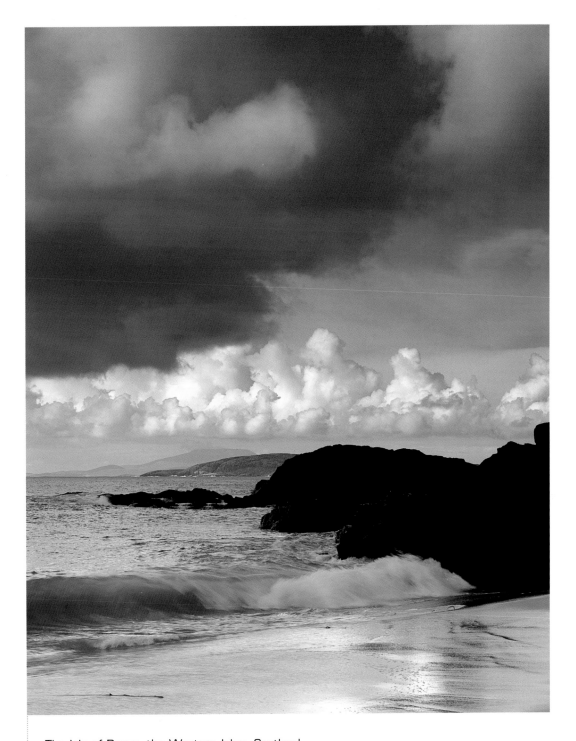

The Isle of Barra, the Western Isles, Scotland

CAMERA: Mamiya RB67
LENS: Mamiya 90mm (Standard)
FILM: Fuji Provia 100
EXPOSURE: 1/15sec at f/32
WAITING FOR THE LIGHT: 1 hour

Choosing the Format

I am, first and foremost, a large-format photographer, my normal equipment being a 5x4in Tachihara view camera. In addition to this, I occasionally work in medium-format (6x7cm) using a Mamiya RB67 if the circumstances so dictate, and recently I expanded my range and bought a panoramic Fuji GX617 (6x17cm) camera. My interest in this latter film size was primarily in response to my picture libraries' regular requests for panoramic landscapes. The image produced by this camera has an aspect ratio (width:height) of 3:1, but this doesn't suit every application and I therefore use this format infrequently. There is, however, one type of subject which I think is tailor-made for panoramic photography and that's the sunset.

I either use my Fuji GX617 to take a wide 3:1 panorama or attach a rollfilm back to my view camera or crop the image from 6x17cm to achieve a 6x12cm (2:1) semi-panoramic image.

In this lovely sunset, taken from the south coast of The Isle of Man, the shape and position of those glorious pink clouds perfectly suited the 6x12cm format. They fill the top half of the frame and bring radiant warmth to the twilight sky. Their presence would have been diminished had I used a squarer format because the picture would have then included a large expanse of featureless sky.

There is always an element of luck with a sunset because you never know how the day is going to end. The sky might look promising but it can so easily deteriorate at the last minute (and vice versa). It all depends on the position of the clouds. Here the horizon is relatively clear, allowing the pink glow to reach the clouds at the top of the picture. Had the clouds been lower – as they often are – there would have been no colourful sky and therefore no sunset.

Cloud tends to accumulate at the horizon and can spoil the colourful display. A clear horizon and a sky with a scattering of shapely white clouds are the ideal conditions for a memorable sunset.

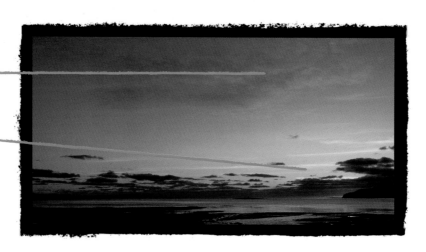

An 81C warm-up filter has been used. A sunset will always benefit from a little warming. To retain a natural look, however, a filter no stronger than 81C should generally be used.

A picture format with the aspect ratio of 2:1 perfectly suited this image, as indeed it does for many sunsets.

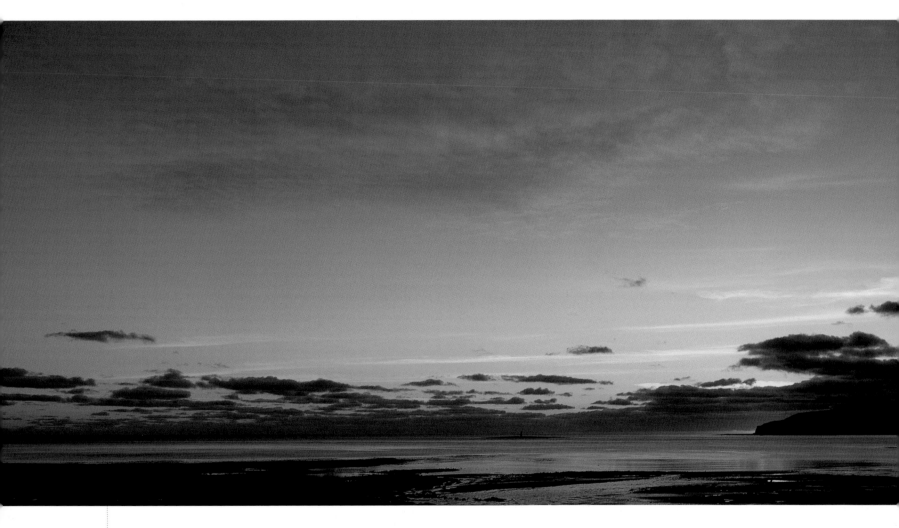

Port Erin, the Isle of Man, British Isles

CAMERA: Fuji GX617
LENS: Fujinon 105mm (Standard)
FILM: Fuji Provia 100
EXPOSURE: 3 seconds at f/32
WAITING FOR THE LIGHT: 1 hour

Autumnal Glory

With the aid of my map I had been making a tour of every lake within a 48km (30mi.) radius of my base in North Windham. Maps can give you certain information about a location, such as size, aspect and the height of the surrounding terrain, but, ultimately, there is no alternative to driving or walking (I use the word loosely) to each lake to assess its appeal and determine the accessibility of suitable viewpoints. This is particularly the case in autumn, when the colour and arrangement of any surrounding trees are likely to be the photographer's main concern.

I had lost count of the number of lakes I had visited and dismissed before I eventually encountered this lovely example of autumnal glory. When I first arrived there was a gale blowing which, coupled with a heavy overnight frost, was rather worrying. Frozen leaves become fragile and are likely to dissipate with every gust of wind, taking with them, of course, the hopes of the anguished photographer.

To my relief, the stormy weather was short-lived and the following morning I returned as dawn broke. The air was still and I was now looking at two rows of trees, one the mirror image of the other. The leaves appeared to have withstood the force of the wind and I set up my camera as the sun began to rise. A slight breeze developed which created rippled imperfections in the reflection. It was barely noticeable and I wasn't unduly concerned. Indeed, I think that a slight variation in appearance between the subject and its reflection can often bring another dimension to a photograph. I added a polarizing filter, which darkened the sky and also strengthened the reflected colour on the water's surface, and then made several exposures.

I had been fortunate. I returned a few days later and many of the trees had lost their leaves. I had, I believe, captured the lake at, or very close to, its peak. Travelling to the numerous other locations that I had dismissed on the way to finding Adams Pond was, in perspective, a small price to pay.

Polarizer (fully polarized)

The colour of both the sky and the reflections on the lake's surface has been strengthened by the use of a polarizing filter.

Maps can only give you so much information. To catch autumn at its peak you must relentlessly search and monitor the landscape as the leaves begin their seasonal change.

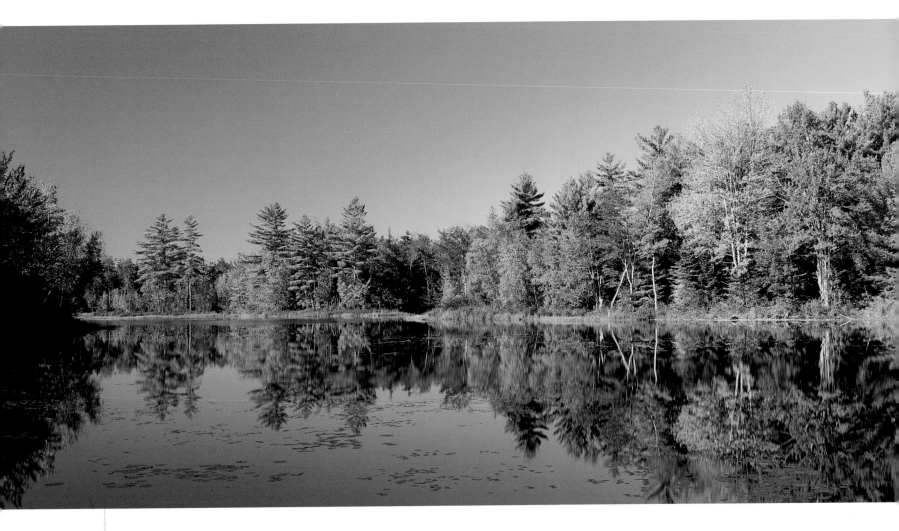

Adams Pond, near Bridgton, Maine, USA

CAMERA: Fuji GX617
LENS: Fujinon 105mm (Standard)
FILM: Fuji Provia 100
EXPOSURE: 1/2sec at f/32
WAITING FOR THE LIGHT: 1 day

Realizing Full Potential

Royden Park Nature Reserve and the adjoining Thurstaston Common cover an area of almost 101 hectares (250 acres). A mixture of heathland, woodland and grassland, its diversity of flora and fauna has qualified it as a site of special scientific interest (SSSI). Its varied species of deciduous and coniferous trees gives it an ever-changing appearance and there is always something interesting, and different, to photograph. It is a pity, therefore, that I don't visit the reserve more often. The problem isn't that it's remote because it is in fact only 6.4km (4mi.) from my home but, like many people, I tend to ignore what is close at hand. Rather than realizing the full potential of my local area, I am inclined to seek out attractions further afield. This 'the grass is always greener somewhere else' approach is wrong and I have vowed to rectify it in the future.

Here I have managed to capture the colours of autumn at their peak. This was not a fortuitous chance encounter; because of their close proximity I was able to monitor the changing leaves on a daily basis and catch them at the optimum moment. This would, of course, have been much more difficult had long travelling distances been involved and it demonstrates the benefit of photographing local subjects.

This view has a raised elevation and a westerly aspect. It is therefore perfect for winter photography, when the bare trees, which are scattered across the sandstone hill, will be silhouetted against the setting sun. I must have missed some glorious sunsets in the past, but they will return again, as indeed will I.

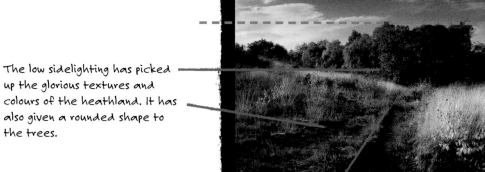

The low sidelighting has picked up the glorious textures and colours of the heathland. It has also given a rounded shape to the trees.

The neutral-density filter has darkened the sky and prevented it from being overexposed. This strengthens the colour of the sky, while the presence of an 81B warm-up filter has accentuated the autumn hues of the trees and grasses.

A centrally placed path is a very strong visual element. A composition built around receding lines will always have depth and a three-dimensional quality.

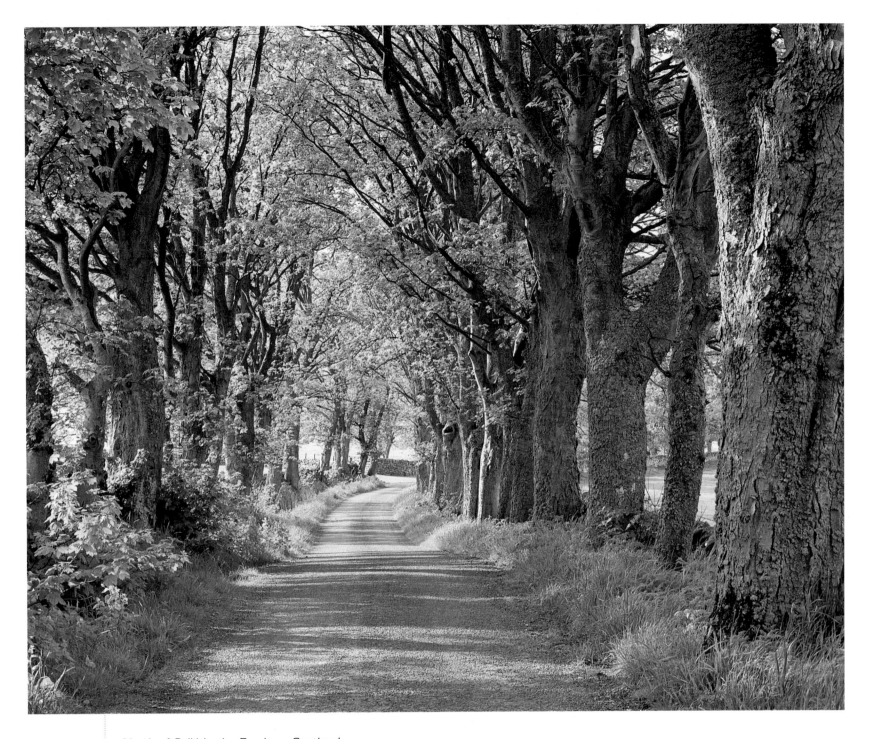

North of Selkirk, the Borders, Scotland

CAMERA: Mamiya RB67
LENS: Mamiya 50mm (Wideangle)
FILM: Fuji Provia 100
EXPOSURE: 1 second at f/27 (sometimes shown as f/22½)
WAITING FOR THE LIGHT: 30 minutes

The Power of Photography

Expansive, open views are not as easy to photograph as you might imagine. All too often the majestic vista you see before you can degenerate into a flat and featureless postcard image when seen as a photograph. You might wonder what happened to the overwhelming grandeur you were experiencing as you set up your camera to capture the magic.

Well, sadly, what you see is not always what you get and this is particularly true in the case of the broad, sweeping view. Why is this? The drawback is that film (or digital chip) can only record light. That is all it can do. It cannot capture the wind in your hair, or the scent of the grass, or the rustle of the leaves. Film is simply a two-dimensional piece of material with a one-dimensional capability. How, then, do you re-create the emotional experience of the landscape given such constraints?

Fortunately photography is a very powerful medium. Its single-sensory ability enables it to capture the viewer's imagination and draw them into a purely visual world, free of distractions. This can be used to your advantage when you have a sweeping vista before you.

My approach is to take the viewer on a journey, starting as close to the camera as possible. This can generally be achieved by including an attractive foreground which falls gently away and then flows into the landscape. This will engage the eye and create the impression of depth. In the absence of close foreground (as, for example, with the photograph here), I will attempt to use highlights to draw the eye into the heart of the picture.

Moving on to the mid- and far distance, I endeavour to maintain interest by using low sidelighting, or broken cloud, to create highlights and shadows; I avoid a flat, evenly lit landscape, as I have found that it will not hold the viewer's attention. Continuing then to the sky, I tend to consider a uniformly blue or grey sky to be undesirable; what I prefer is the presence of an attractive cloud structure, which will draw the eye upwards and complete the visual trek across the landscape.

I find that approaching an open view in this way usually produces pleasing results. However, if I am not completely happy with what I see then I will, if possible, return at another time of day (or year); a change in the direction of the light can make a world of difference.

Low sidelighting filtering through broken cloud is the essential ingredient. In a large view, scale, contour and depth can only be depicted with the right quality of light.

A strong sky continues the powerful rugged theme of the picture. To achieve this a two-stop (0.6) neutral-density filter was necessary in order to prevent the sky appearing thin with washed-out highlights.

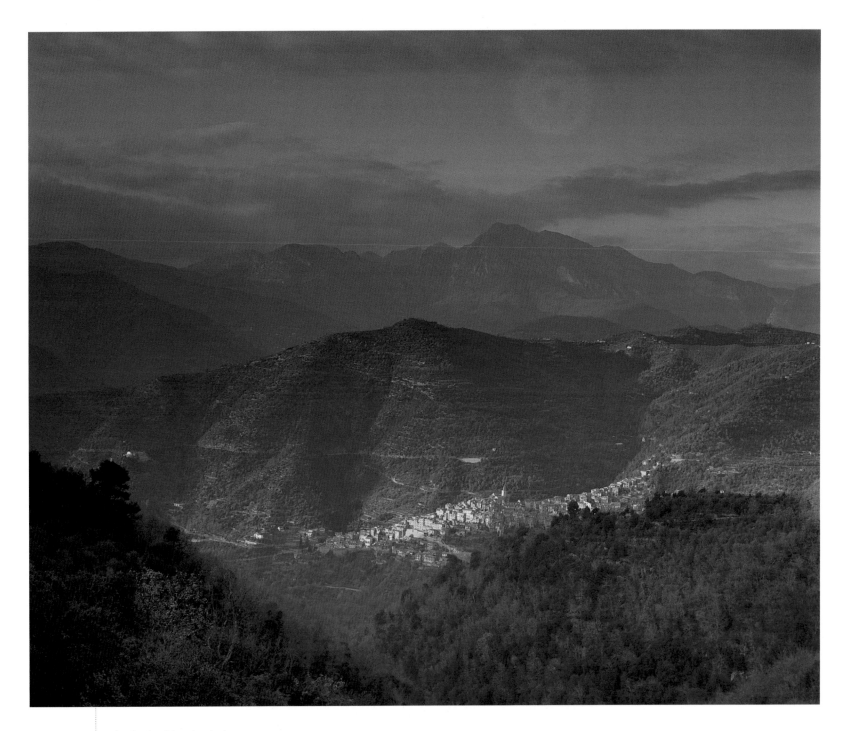

Apricale, Liguria, Italy

CAMERA: Mamiya RB67
LENS: Mamiya 50mm (Wideangle)
FILM: Fuji Provia 100
EXPOSURE: 1/8sec at f/22
WAITING FOR THE LIGHT: Immediate

Critical Timing

Curiously, the Forest of Bowland is a forest with no trees. Well, that's not strictly true. There are trees scattered around but by no means in the numbers you would expect to find in a forest. Apparently it was tree-clad several hundred years ago but the land was cleared for farming.

The lack of forestation does not, however, detract from the appeal of the area, and indeed I rather imagine it has improved it. The landscape is now a group of fells and is essentially a mixture of farmland and moorland. There is a pronounced undulation and it is altogether a most agreeable place.

I often spend a day or so there en route to Scotland. I have visited the old barn you see here on many occasions and have photographed it at different times of day and in all types of light. Having built up a fairly intimate knowledge of the location I can say with a degree of confidence that the timing of this photograph was critical.

This picture was taken on a November morning at 10.30. The sun was low and slightly to my left. You can see that it is just clipping the inside of the stone wall and this is the key to the photograph. Earlier than 10.30 the wall was frontally lit and looked flat and by 10.50 it had begun to cast a shadow over the richly coloured grasses. There was therefore just a 15–20 minute period when the light was favourable.

Any subject with a craggy or roughly textured surface that you wish to emphasize will require a specific angle of light and you will therefore need to photograph it at a precise time. You can only determine the best time by watching as the sun passes through its arc.

A straight horizon can often be improved by the presence of an interesting sky, which will normally benefit from the presence of a neutral-density graduated filter.

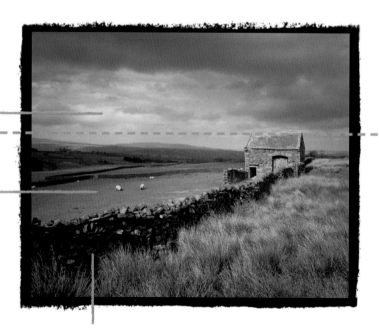

One-and-a-half stop (0.45) neutral-density graduated filter

Watch for movement in a flock of sheep. Blurred animals will spoil a picture.

The sunlight clipping the stones is an important feature and had to be carefully timed.

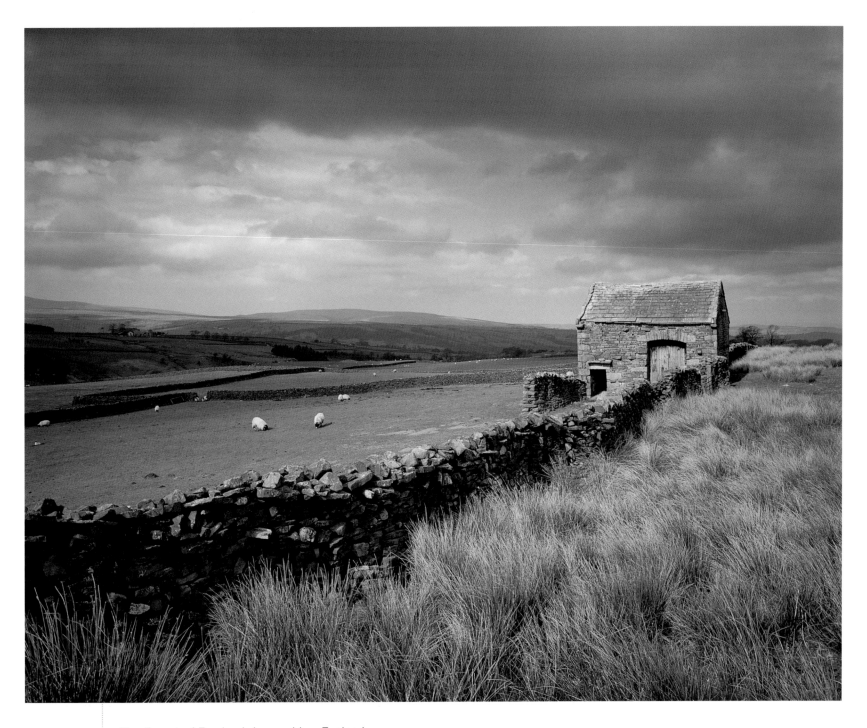

The Forest of Bowland, Lancashire, England

CAMERA: Tachihara 5x4in
LENS: Super-Angulon 90mm (Wideangle)
FILM: Fuji Provia 100
EXPOSURE: 1/2sec at f/32
WAITING FOR THE LIGHT: 30 minutes

One for the Future

I was spending a week on the Isle of Lewis with two fellow photographers. Our week together has become an annual event and every year we make the pilgrimage to a far-flung corner of Britain. It doesn't get much further (or better) than the Outer Hebrides group of islands.

This marvellous cove is hidden away on the west coast of the island. It is part of a sweeping bay and is only accessible at low tide. It was therefore fortunate that we arrived when we did, as it was the last day of our week. Had we arrived a little sooner or later then we would never have discovered this Aladdin's Cave of treasure.

We had gone our separate ways to make our own explorations and, when I stumbled upon the cove, my two companions were nowhere to be seen, which was worrying. I could see that the tide had turned and it was now time which was ebbing away. All my equipment was

locked in our vehicle, the keys to which were in the pocket of one of my absent friends. I've lost pictures through rain, wind, people, animals and many other reasons which don't come to mind at the moment, but never because my camera was locked away in somebody else's car – and that wasn't an addition to my list of failures I wanted to make!

After some ten minutes of frantic searching and yelling I was reunited with my companions and we all ran back to the cove collecting our equipment on the way. Waves lapping round our ankles provided the incentive to work quickly and fifteen minutes later it was all over. We waded back to the car then sat and watched as the beach disappeared under the rising tide.

One day I would like to return to this bay to make a more leisurely assessment of it. This is, I think, one for my little black book.

This photograph is just one of many waiting to be discovered in this beautiful cove. Places like this are a joy to find and will yield many delightful images.

The polarizing filter has suppressed reflected light on the surface of the rocks and has strengthened colour.

An 81B warm-up filter was used. Stones and rocks often benefit from the addition of a warm-up filter.

Polarizer (fully polarized)

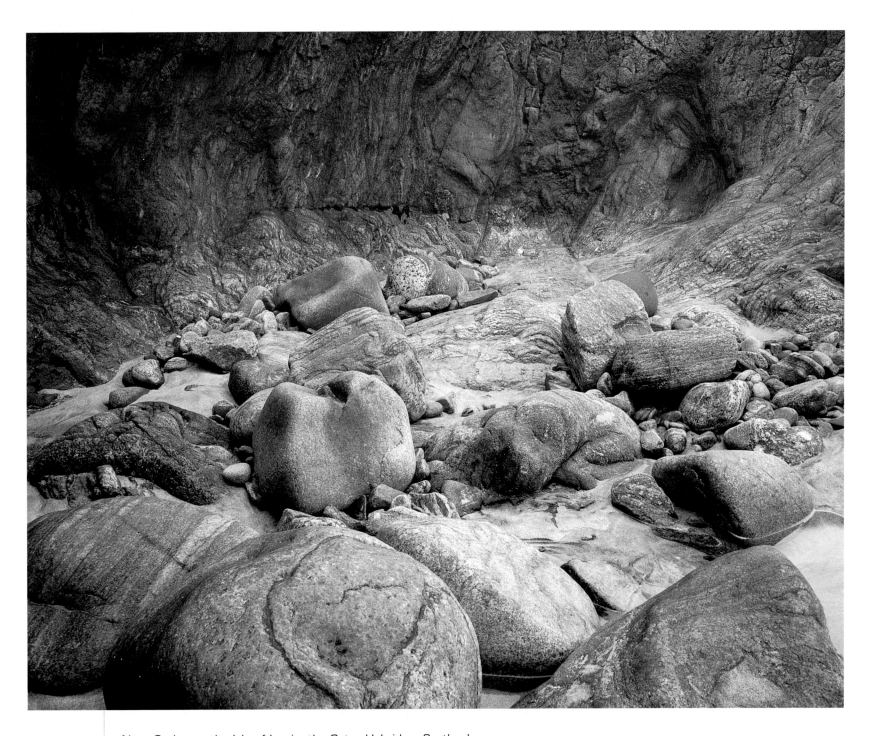

Near Carloway, the Isle of Lewis, the Outer Hebrides, Scotland

CAMERA: Tachihara 5x4in
LENS: Rodenstock 120mm (Semi Wideangle)
FILM: Fuji Provia 100
EXPOSURE: 2 seconds at f/32
WAITING FOR THE LIGHT: Immediate

A Winter's Dawn

The Hardknott Pass is one of Britain's narrowest, steepest, most twisting roads and, at 6am on an icy January morning, one of its most hazardous. Not surprisingly, I had the road to myself and I was thankful for this as my four-wheel-drive vehicle slithered towards the top of the mountain. I was in no hurry. I had a dawn picture planned and I had an hour to spare. The abundance of time was, in fact, to prove fortunate, as I was soon to discover.

I arrived at the summit and, as I stepped out of the car, I was almost blown over by the gale-force winds that were battering the mountain. It would have been impossible to photograph in those conditions; I had to find a sheltered spot if I was to have any chance of capturing my sunrise. My spare hour was then taken up by my searching by torchlight for a vantage point that would provide me with both an open view and some protection from the wind.

I eventually found a position but it was far from ideal. I was crouched between rocks with barely space to move. Setting up my camera was slow and laborious (I didn't at the time have my medium-format equipment and was restricted to using my view camera) and I was just in time to catch the dawn glow at its peak. I managed only two exposures before the sun was swallowed up by a descending blanket of cloud.

The unfavourable conditions had forced me to modify my normal technique. To reduce the possibility of wind-induced camera shake I used an exposure of 1/60sec at f/11. This dictated that I push the film from ISO 100 to 400, i.e. a total of two stops. If you look closely (although I would prefer it if you didn't!) you can see the effect of this. The combination of a relatively wide aperture and the increased film speed has resulted in a lack of critical sharpness, particularly in the foreground. This is regrettable but not a disaster, because to me this is a picture for the eye to roam over. It is not about fine detail; this is a photograph of mood and atmosphere. Lack of detail does not diminish this, indeed in many ways I rather think it enhances the stark reality of a winter's dawn.

The majestic colours of dawn are normally fleeting in their appearance. You must be ready and waiting to catch them at their peak.

The grainy appearance of the picture is a result of the film being pushed by two stops to a speed of ISO 400. I do not recommend the practice but it can be done as an emergency measure when there are no alternatives.

A two-stop (0.6) neutral-density graduated filter was used. When photographing a back-lit sky (i.e. when facing the sun) a strong neutral-density filter will always be necessary if overexposure of the sky is to be avoided.

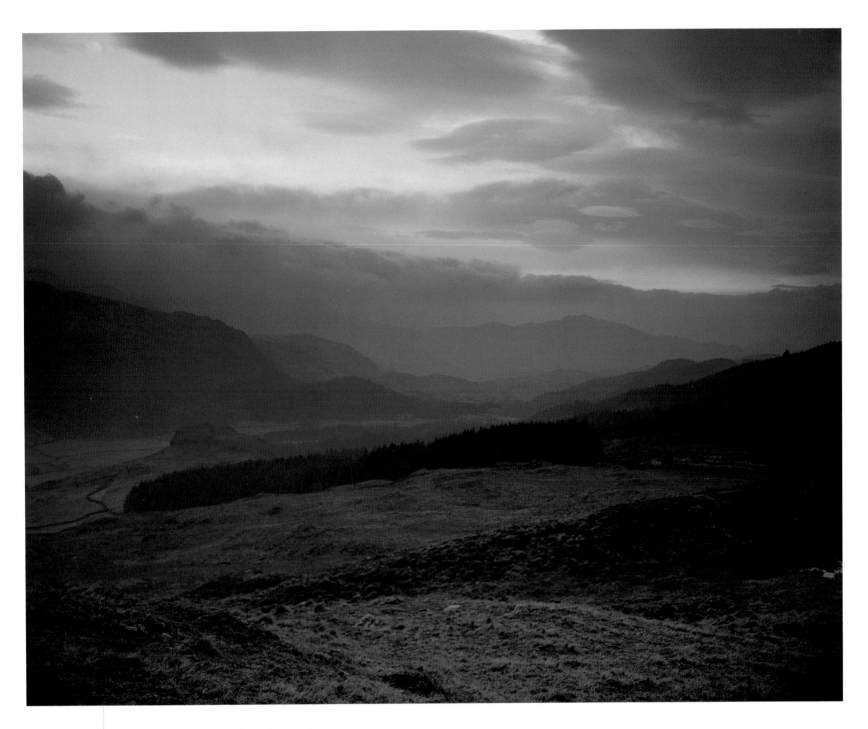

Hardknott Pass, Cumbria, England

CAMERA: Tachihara 5x4in
LENS: Super-Angulon 90mm (Wideangle)
FILM: Fuji Provia 100 (rated at ISO 400)
EXPOSURE: 1/60sec at f/11
WAITING FOR THE LIGHT: 5 minutes

Perfect Timing

Eilean Donan Castle is one of the most photographed monuments in Scotland, and it is easy to see why. Approaching the Kyle of Lochalsh from the road the castle sweeps majestically into view against a romantic backdrop of sea, mountain and sky. Its location is quite perfect and it simply begs to be photographed.

I must admit that I approach this type of popular attraction with more than a little caution. There are two reasons for this: firstly I am always reluctant to repeat photographs that have been taken by others, and secondly, being realistic, the chances of my improving on what has been done before are slim. This is because photographers who live in the vicinity have the opportunity to visit a location often and monitor the light and weather conditions. They are therefore more likely to capture the perfect moment than the visiting photographer, who has to make the best of what he or she is presented with. On such occasions, therefore, my camera usually remains in its case.

This time, however, the romance of it all was getting to me. I took in the castle, the mountains, the lapping waves, the passing clouds and of course the atmosphere. I was being wooed and my resistance was weakening. I began to wonder how I could create an image that would adequately portray the magnificence of what was before me.

I had a feeling that the castle was flood-lit at night and my enquiries at the visitor centre confirmed this. I was, however, also informed that the precise time of illumination could vary, which was worrying. If the castle was illuminated too late then the sky would have lost its twilight and the mid-grey tones you see here would have been reduced to an unattractive, solid black mass. I was therefore very relieved when the castle was suddenly bathed in light as I was setting up my camera.

The daylight gradually faded and I began taking spot readings of both the sky and the castle. Fifteen minutes later, the light was balanced and I made several exposures, bracketing half and one stop above and below my meter reading. I then stood and watched as darkness slowly descended. I didn't want to leave. Well this is, after all, one of Scotland's finest locations and maybe I just wanted to drink in the atmosphere. Or perhaps it was something else. Perhaps I knew that I had been lucky to arrive when I did. I think I simply wanted to savour the moment.

Timing is all-important when photographing a flood-lit building. To ensure detail is recorded in both sky and building the respective light values have to be closely matched. There is, perhaps, a span of no more than ten minutes when the required state of equilibrium exists.

I would normally favour a clear sky at dusk but I think the setting of the castle requires a more atmospheric backdrop. The dark, brooding nature of the clouds, mountains and sea all contrast perfectly with the brightly lit castle and gives it the prominence it deserves.

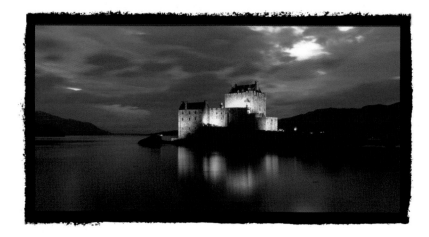

I bracketed exposure using shutter speeds of five, ten and fifteen seconds, as you can never be certain which exposure will produce the best result. Reciprocity failure must also to be taken into account and it can affect different film in different ways.

Forest of Tranquillity, NSW, Australia

CAMERA: Tachihara 5x4in
LENS: Rodenstock 120mm (Semi Wideangle)
FILM: Fuji Provia 100
EXPOSURE: 4 seconds at f/38 (sometimes shown as f/32½)
WAITING FOR THE LIGHT: Immediate

Adopting the Right Approach

The lack of control we have over our environment will always be a source of frustration but, with the right approach, it is possible to minimize the disappointments and failures you might experience. With a little careful planning and preparation you can boost your chances of enjoying many successful and rewarding photographic excursions. There are a few simple procedures you can adopt.

Equipment

Examine, test and, if necessary, clean your equipment before embarking on any trips. If you are unfamiliar with the operation of a piece of equipment – such as a newly purchased item – then practise using it in advance, at home – not as you are about to take a photograph! Read the user manuals and take them with you for reference. Check all batteries and carry a spare set – you can guarantee that a battery will fail at the worst possible moment.

Where to go

Choose your destination carefully. Have a clear idea of the type of image you wish to take and select your location accordingly. Large-scale maps (1:50,000 are ideal) will tell you everything you need to know about an area. The contour lines are the key to reading a landscape. The closer together they are, the steeper the terrain. Other features, such as forests, orchards, lakes, rivers and footpaths, are also shown. By carefully studying these maps you can get a feel for a location. You can therefore choose a destination and know what to expect when you get there.

Llantysilio, Denbighshire, Wales
I have visited this valley on many occasions over the years. It cuts through a sprawling expanse of mountains and undulating hills. Its appearance changes throughout the year and throughout the day but my repeat visits have given me a comprehensive knowledge of its nooks and crannies and moods and whims. This has taken time and effort but I have been well rewarded.

When to go

The 'when' is as important as the 'where'. Each of the seasons has something to offer and it is often worth visiting the same location at different times of year because you will always find something new. This approach will also enable you to become acquainted with a place and learn the nuances of its light.

Autumn and winter are normally the seasons favoured by photographers but the spring and summer months shouldn't be ignored. Although light tends to be flatter in the summer, broken cloud can create interesting effects. Photographing in the early morning and late evening can also be rewarding at this time of year. Flora is more abundant in the sunnier months too, so it really is an all-year-round pursuit.

Make repeat visits

Don't be disappointed if you don't get it right first time (you will by no means be alone in this respect). If possible, return and keep returning until you are satisfied that you have seen, and successfully captured, a location at its best. Above all else this is, perhaps, the most important recommendation to follow because there is no better way to learn than to analyze and improve on your own photographs.

Near Mouldsworth, Cheshire, England
Fields of wild flowers must be closely monitored if the peak display is not to be missed. Living relatively close to this meadow I was able to follow its flowering during the spring and early summer and capture it at the optimum moment.

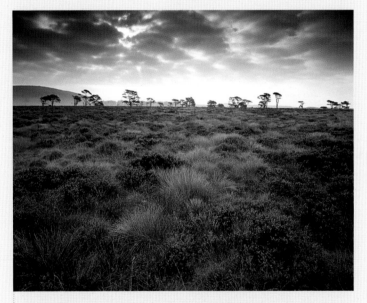

Near Malham Tarn, North Yorkshire, England
This location is well off the beaten track. I discovered it by exploring using my Landranger 1:50,000 scale map. To avoid the risk of missing interesting features I always carry a large-scale map when visiting unfamiliar territory.

A Final Note: Embracing the Future

I was given my first camera in 1963. (I was, I should add, very young!) I must admit that it wasn't by choice. I had my heart set on a bike but the powers that be (i.e. my parents) deemed a camera to be the more suitable reward for a modest degree of early academic achievement. My enthusiasm was therefore rather muted, so the camera remained in its box for several months. Eventually, it was the imminence of a family holiday that prompted me to take a closer look and, to my surprise, I became vaguely interested in the idea of taking photographs.

What I liked about the camera was the 'high-tech' specification. Instead of the then commonplace symbols of sun, half-sun and cloud, there were numbers and letters around the lens. I can still clearly remember them: 1/125, f/8, f/11 and f/16. How interesting, I thought, I wonder what they mean. I was intrigued and it was at that point that my fascination with photography was forged.

So, my first photographs were taken with a fixed shutter speed, a fixed-focus lens and just three apertures. It seems primitive now but it was sufficient to get me started and, essentially, it was sufficient for me to learn with. Shortly afterwards I was fortunate to progress to what I considered to be a 'proper' piece of equipment when I was allowed to borrow a friend's 35mm camera. I was overjoyed. At the time it seemed as if I had the very latest state-of-the-art engineering at my disposal: a variable focus f/3.5 lens, a built-in rangefinder, depth-of-field guide, variable shutter speeds of between one and 1/400sec and, to cap it all, I had the use of a separate Weston Master V exposure meter. I had well and truly taken my second step up the technology ladder – but I was eager to climb higher.

And so it continued. I gradually upgraded my equipment and moved on to a 35mm SLR camera, this was followed by medium format and then finally, in 1990, to my large-format 5x4 system, which I have used ever since. But the process of natural evolution didn't end there. A few years later, I bought a film scanner that enabled me to produce digital files of my photographs. This was then followed by an inkjet printer, which produces very high-quality prints from my scanned images.

Near Penzance, Cornwall, England

This picture was taken a good 40 minutes before sunset and it was therefore fortunate that I had arrived early. This proved to be the peak moment because the vivid drama you see here faded shortly after the picture was taken and the day ended on an anti-climatic note. I always like to arrive at a location in good time – sky watching is never time wasted.

CAMERA: Fuji GX617
LENS: Fujinon 105mm (Standard)
FILM: Fuji Provia 100
EXPOSURE: 1/2sec at f/32
WAITING FOR THE LIGHT: 1 hour

Photographers' Institute Press, Castle Place, 166 High Street, Lewes, East Sussex, BN7 1XU United Kingdom

Tel: 01273 488005 Fax: 01273 402866 Website: www.pipress.com

Contact us for a complete catalogue, or visit our website.
Orders by credit card are accepted.